ART OF THE NINETEENTH CENTURY

ADOLF MAX VOGT

WEIDENFELD AND NICOLSON
5 Winsley Street London W 1

English translation by A. F. Bance

Martin Fröhlich, who holds a degree in architecture from the Federal University of Technology, Zurich, assisted in the picture research and wrote the captions to the chapter on architecture. In addition, he contributed "Historicism" and "New Challenges to the Architect." Thérèse Peter undertook documentary research and the preparation of the manuscript. I wish to express my thanks to both for their collaboration. *A.M.V.*

First published in Great Britain by Weidenfeld and Nicolson
5 Winsley Street, London W 1
English language translation © Weidenfeld and Nicolson 1973
SBN 0297–99445–x
Printed in Germany

CONTENTS

Front of jacket: Auguste Rodin, The Thinker. 1880. Bronze. Musée Rodin, Paris.
Back of jacket: Joseph Mallord William Turner, The Burning of the Houses of Parliament. 1835. Detail.
Museum of Art, Cleveland, Ohio.

INTRODUCTION

Works of art are generally approached from three main critical standpoints: intention, method of production, and result. We are not, here, concerned with the first two: our object is to compare the results of creative processes—the structures, the color harmonies, and the final effects of form, space, and composition achieved.

To approach art history in this way is to analyze it on the basis of style. "Greek" and "Roman," "Romanesque" and "Gothic," "Renaissance" and "Baroque"—all are stylistic designations, describing more than the achievements of a particular geographical region or a given period of time. What is the extra dimension that changes the geographical term "Greek" or the originally deprecatory "Gothic" into a designation of style? It consists of identifying the unity of manner and means. If we say that a painting, or the work of an architect, or the artistic achievements of one or more generations have style, what we are saying is that in them there is a visible and tangible relationship of manner and means. It follows that to write a history of style is to observe the changes in the relationship of manner to means, noting the degree of closeness or looseness in the fabric of this relationship—surveying its levels of interaction and the unity it presents.

All this may amount to nothing more than obvious truths. But it would be foolish to lose sight of them, particularly in a discussion of the 19th century, an era that has been charged—justifiably—with failing to achieve any consistent style of its own. Critics who attempt to outline the stylistic history of the period find themselves hedging with such words as "nevertheless," as they point out, with elaborate care, every real or imagined instance of unity.

Such a contrived analysis will certainly run the risk of distorting the true sequence of achievements during the period 1800 to 1900, and of exaggerating the degree of unity and coherence present. But whether or not we decide to force the products of the period into a preconceived unity of manner and means, there is one factor we have to come to terms with: the epoch itself was extraordinarily and obstinately concerned with this problem of unity of style. There is no era in European history that talked so much or so self-consciously

about style as the 19th century; and it was during this period that, in both building and painting, foreign and ancient styles were adopted and revived on the grand scale.

To build or paint in recognized styles, but to have no style of one's own, is to be either a failure or an experimenter. To cite a well-known example: when Heinrich Hübsch (1795–1863), an architect in Karlsruhe, published a pamphlet in 1828 with the title *In What Style Should We Build?*, he was displaying either a new perplexity or, possibly, a novel freedom of choice. More precisely, it might be said that he was demonstrating both at once.

To overstate the case, in 19th-century Europe we are confronted with something new: man had lost the naive possession of a style and was faced with the need to choose one. This situation had previously occurred in isolated instances (the work of Andrea Palladio in the 16th century shows it well, for example), but between about 1730 and 1750 the determined quest for style became universal in Europe.

The problem of the possible reasons for this new development inevitably presents itself. So thorough was the change that it can hardly be termed a "transformation of style" (like that from Romanesque to Gothic or Renaissance to Baroque). This breakaway, occurring at first only in Europe, is a loss-gain situation that is unique; it deserves our fullest attention.

A Century Sees Itself As an Era—An Era Sees Itself As a Century

The Gothic age did not talk of itself as "Gothic." But from the very beginning, the 19th-century *saw* itself as a century. It is well known that Schiller's *Don Carlos* (1787) "challenged his century." The spirit of the challenge was not new, but the object of the challenge was. A dozen years later, on July 21, 1798, before the battle of the Pyramids, Napoleon confronted his troops with the same kind of challenge: "From these pyramids forty centuries look down upon you" ("Du haut de ces pyramides, quarante siècles vous contemplent," and, at another time: "Soldats, quarante siècles vous regardent!").

In both cases it was neither a divinity nor a theological, ecclesiastical, or political power that was invoked, but time itself, and that in the favorite form of one hundred years. This favorite concept eventually became so prominent in 19th-century consciousness that by 1888 the catch phrase *fin de siècle* found a great response (it is the title of a comedy by Jouvenot and Micard). Men seemed to experience the century drawing to its close, and they precociously defined the situation themselves: a concept of decadence was linked—quite irrationally—with the declining remnant of this arbitrary period of one hundred years.

It is no accident that the same 19th century took up the idea of the decimal system to standardize weights and measures and eventually saw it adopted internationally. The notion

of making the meter a basic unit of measurement was conceived during the French Revolution (the meter was taken as a decimal fraction of a quarter of the earth's meridian). In 1791 this proposal by an Academy commission became a decree in Paris. In 1889, or almost one hundred years later, the metric system was recognized by most states—with the exception of the Anglo-Saxon countries—as standard.

The metric system spread out from France, and by the end of the 19th century its value had become self-evident. It not only had the advantage of international standardization; it meant, too, a thorough "decimalizing" of thinking, conceptualizing, and dealing (for the school child, the series 1:10:100 became cardinal), and an equally thorough break with human measurements. For it was the human units of measurement—the handspan, the ell (yard), the foot—that were now relinquished in favor of the meter: an abstract, nonvisual quantity derived from the meridian that everyone could imagine conceptually but could not visualize.

The handspan, the ell, and the foot were highly actual and graphic human units of measurement, but imprecise, of course, since they varied from person to person, from one race to another. The 19th century could no longer tolerate this imprecision, for it was by no means only the "quill-driving century"; above all, it was the measuring century, and, furthermore, the first century to measure accurately. Faced with the alternative of imprecise but human, or precise but abstract, systems of measurement, it chose accuracy every time.

The role of abstract numbers and exact measurement in the architecture of the period can be illustrated by two examples: The project for the Eiffel Tower (*Ills. 3, 32*) was announced with a kind of number-magic as "a tower of 1,000 feet or 300 meters"; and Paxton decided that the length of his Crystal Palace for the London Great Exhibition of 1851 should be precisely 1,851 feet (*33, 37*).

Such number-conjuring, sometimes to the point of the ridiculous, bears witness to the dominant part played by numbers in the thinking, research, and creative activity of the era. And the spectacular 19th-century developments in medicine, in chemistry, and in science generally are greatly indebted to accurate counting and measuring. It is not surprising that this era, with its preference for the exact, abstract decimal standard, was prone to conceive itself in decimal terms: as one hundred years—a "century."

Europe Builds and Paints Its Own History

The 19th century not only developed and introduced the metric system; it also evolved something like a historical system. We may concede that every era and every place has

always had and passed on its own body of historical knowledge; but the 19th century is the first to feel the need to "measure" history—that is, to express it in terms of accurate dating. Myths, heroic epics, fairy tales, and sagas were now finally replaced by exact historical research, or, rather, stories, sagas, and epics became the objects of exact research, being examined scientifically for their factual content, for their probabilities and improbabilities. This applies not only to national and military history, but also to the history of the arts. For example, Heinrich Schliemann (1822–90), the famous archeologist who discovered Troy and the Mycenaean grave treasures, was led to these finds by a painstaking examination of the Homeric epics.

A logical complement to the passion for measuring history precisely is the precise dating of ancient architectural monuments. Certainly, Palladio had carried out relatively accurate surveys of ancient monuments on Italian soil; in 1676 and 1677 Antoine Desgodetz had accurately measured the Pantheon in Rome. The 19th century, therefore, cannot claim all such "firsts" for itself. What distinguishes its approach to history is, rather, a second phase or level of application: measuring served to make historical forms available for contemporary use. After 1750—or, at the latest, after 1800—knowledge of building history and of historical models was so extensive and accurate that there was a temptation to put this knowledge to work—in other words, to build history itself. It is England that first began to build in the Gothic style (James Wyatt, Fonthill Abbey, 1795–1807; 4), as well as the Classical, and soon after 1800 architects even began presenting their clients with a choice of styles: in his design for the Werder Church in Berlin, the German architect Karl Friedrich Schinkel produced both Renaissance (1) and Gothic (2) versions. The Gothic version (called neo-Gothic) was selected and executed, on the grounds that Gothic forms were felt, understandably, to be more "Christian" than Renaissance ones.

The freedom to choose a style would seem to be a crucial matter, because it represents a unique intrusion of historicity into the present. The measuring and appropriating of past achievements reached such a point that the knowledgeable Sorcerer's Apprentice could no longer control the power he had conjured up. At the same time, we must bear in mind that the preoccupation with choice of style belonged only to the more "elevated" architectural projects; if we line up the most important 19th-century building undertakings— church, monument, prestige edifice, housing, hall, tower, bridge, transportation facility (steamship, railroad)—it is apparent that only in the first three was choice of style a question. Housing was largely undisturbed, and functional building, from hall to steamship, was completely free from such stylistic considerations. In many cases, of course, the margin for creativity was greatly reduced by the demands of engineering. While the "elevated" tasks made very few structural demands on the 19th-century architect and gave

him a wide latitude for experimentation (which he then directed toward problems of style), the more prosaic assignments—a wide-span station concourse or exhibition hall, a high tower, a long-span bridge, a steamship—imposed such firm structural limitations that the opportunity for stylistic embellishment was limited or almost nonexistent. However, it is precisely those buildings that were almost "pure" engineering—Paxton's Crystal Palace, Eiffel's Tower—that aroused the grudging admiration of contemporaries and are now more highly regarded than much of the "stylish" architecture of the period.

Further limitations are imposed on the architect or engineer when he is confronted by a challenging force that may endanger his project. For a tower of 300 meters, for instance, wind pressure is a challenging force. Eiffel and his colleagues faced the challenge and, through calculations, evolved a novel construction that has stood the test of time. By virtue of this fact, the structure they designed possesses style. In exactly the same way, Paxton's glass construction (*33, 37*) and Dutert's Exhibition Hall (*42, 43*) have style. For style does exist in isolated areas in the 19th century, mostly in quite unexpected places and for the most part in "commonplace" projects. Invariably, when the challenge was so great that it threatened to defeat an idea, the 19th century found the very unity of manner and means—the coherence—that we today honor with the word "style."

But the next question is: why did the 19th century always have to push toward the quantitative limits (a hall of wider span, a higher tower) before it found this coherence of manner and means? The question can be answered not by art history but by the cultural history of the period.

Explosion of Range

The age of Napoleon, revolution and restoration, the founding of nation states, the imperialism of the Victorian era—these stages of political development indicate Europe's path to the mastery of the whole planet. A small part of the world, politically disunited and torn by rivalries, was able—temporarily—to gain command of the rest of the globe and its oceans. This position of power, which caused (and still causes) much suffering, and above all humiliation, to the non-European peoples, could not be achieved merely by political skill or military strategy; it was also a product of the superior technology of civilization.

The real victory of Europe and the submission of non-Europe was not gained in this or that sea battle, land battle, or blockade; it came precisely when the non-European peoples felt themselves forced to adopt the civilizing style of Europe. If we wish to pinpoint this

moment, we might ask: when did the court of the Russian tsar, the Ottoman sultan, the Japanese emperor begin, not only to speak European languages and thereby to acquire the Latin alphabet, but also to adopt the Western manner of sitting, eating, and dressing, to accept European medicine, to employ Western communications techniques?

When, in 1869, the Suez Canal was solemnly inaugurated, the leaders of the Western colonial powers assembled to celebrate a red-letter day. The occasion for the festivities was, in fact, the triumphant extension of the range of colonizing power offered by the Canal. The Empress Eugénie, the representative of France, was invited to stay with the Sultan on the Bosporus after the ceremonies. In Constantinople she moved into the Palace of Beylerbey, which was specially fitted out in Western style. Architecture, furniture, chandeliers, bathtubs, and toilet stands were all in the European mode, though naturally decorated with neo-Ottoman motifs. But how little this decoration means in comparison with changes as basic as that of seat height (from 30 centimeters—the Ottoman sedir—to 45 centimeters, the European chair). This difference of 15 centimeters has a world of meaning! The capitulation of the Russian, Ottoman, and Japanese life styles to the Western was far more incisive and decisive than a military surrender. Capitulation to the white race was conceivable only as a consequence of the expanded range of influence enjoyed by 19th-century European civilization. This included an extension of the range of armament, thanks to inventions like that of the needle gun (1836) and the development of explosives (dynamite, 1867); the range of the transport network, spatially extended and temporally reduced by the development of steamship and railroad; the range of communication, decisively altered by the invention of the telegraph (1837), the telephone (1876), and the radio (1895).

These developments so conclusively altered the range, not only of power, but also of knowledge, that it is possible to argue that they are responsible for a new European behavioral pattern, even a new organization of the human senses. A new generation came into being that had such a firm command over space and time—for example, by means of the radio—that it seemed able to bridge them. The significance of this 19th-century explosion of range can be put into perspective by a glance at various earlier civilizations.

Range and Its Phases

The history of the reach of civilization falls into quite different stages than the history of styles in art. It seems reasonable to make four broad divisions:

Phase 1: The natural range of the Greeks

In about 800 B.C. the distance from pillar to pillar corresponded roughly to the span of a man's outstretched arms; the corbel (or "false") vault allowed this distance to be increased by four or five times. Speed of communication as measured in terms of the Marathon runner was 42 kilometers in two hours. Compared to other highly developed early civilizations, the Greeks achieved no extension of range, but they did replace building with wood by building with stone, to attain greater permanence.

Phase 2: The artificial range of the Romans

At the time of the birth of Christ, the combination of true vaulting and the basilica system allowed a great increase in span (seen in the baths, for example). Improvement in communications (road network, galley system) made it possible for the Romans to dominate the whole Mediterranean area. Rome was the first of the early civilizations to succeed in drastically expanding natural range. The Empire lasted just as long as the range could be maintained.

The Middle Ages saw a relapse into natural range and the attempt by various peoples to reestablish the civilizing range of the Roman Empire.

Phase 3: The artificial range of the Renaissance

With the building of St. Peter's in Rome (1506–1615), the huge span of the ancient Romans was not only regained, but surpassed. By circumnavigations of the globe, political range was extended at a stroke. The invention of printing provided the first technique of reproduction, giving access to inexpensive copies of texts, and the aural culture (of antiquity and the Middle Ages) became a literary culture.

Phase 4: The artificial range of the 19th century

Span was increased by construction in iron and by three-centered arches; a new range of communications was introduced by the telegraph and telephone. The invention of photography—400 years after that of printing—meant an optically exact technique of pictorial reproduction that seemed to make the painter redundant. It preserved and reproduced like printing, and also mechanized the making of the image, surpassing in quantitative accuracy the products of hand and eye.

This sketch of the history of human range, confined to the aspects most relevant to the fine arts, gives an idea of the expansion of sense perception that occurred in the 19th century. It is the senses of sight and hearing, above all, whose scope is dramatically widened,

and the extensions cannot be underrated, even when they seem to be merely quantitative changes. They touch upon art—indeed, they affect it fundamentally.

An example of the effects of photography in rivaling (ultimately transforming) 19th-century art can be seen by comparing illustrations *5* and *6*. An impartial observer of the two pictures—a self-portrait of the painter Ingres of 1858 and a photograph of the philologist Littré, taken by Petit about 1860—will have to admit that the photograph is as expressive as the painting. The academic's crusty, obstinate, but intelligent manner is impressively captured by this early masterpiece of the camera. Without doubt, pictorial artists of the 19th century felt challenged by the competition of the new medium. Sooner or later the effects had to be felt in their painting.

Information, Reproduction, Preservation

Informing, reproducing, preserving—Europe's 19th-century superiority lies in these three achievements of its civilization.

1, 2 KARL FRIEDRICH SCHINKEL (1781–1841), DESIGNS FOR THE WERDER CHURCH, BERLIN. Built 1824–30. In 1828 the architect Heinrich Hübsch published an essay entitled *In What Style Should We Build*?, and this question became the overriding artistic preoccupation of his generation. Schinkel illustrates the dilemma by presenting his clients with a choice of two solutions, Renaissance (*1*) and Gothic (*2*).

3, 4 "BARE" AND "CLAD" ARCHITECTURE: ALEXANDRE-GUSTAVE EIFFEL (1832–1923), 300-METER TOWER. World's Fair, Paris. 1887–89; JAMES WYATT (1746–1813), FONTHILL ABBEY. Near Salisbury. 1795–1807. Strangely enough, it is possible to juxtapose the iron lattice of the Eiffel Tower (*3*) with a neo-Gothic hall without too violent a visual clash. The relationship between the two lies, first, in the method of construction, openly revealed in one, concealed in the other; secondly, both buildings are inspired by the same historical period, the Gothic. While the architect Wyatt takes Gothic as his model in matters of style and form, the engineer Eiffel adopts the constructional principles of the audacious Gothic builders, reinterpreting them in a modern idiom.

5, 6 THE ARTISTIC IMAGE AND THE MECHANICAL IMAGE: JEAN-AUGUSTE-DOMINIQUE INGRES (1780–1867), SELF-PORTRAIT. 1858; MAXIMILIEN-PAUL-ÉMILE-LITTRÉ (1801–81), photographed by Petit. c. 1860. Even at this early stage, the photograph (*6*) is capable of capturing qualities of personality as well as the purely external image. Are these qualities artistic or non-artistic? Should we consider the photographic portrait of the scholar as less expressive than the self-portrait of the painter (*5*)?

7, 8 THE GREEK PORTICO IN THE un-GREEK CONTEXT: EUSTON STATION, LONDON, 1835–39, illustrating the Doric temple front as motif for a railroad station; ROLLS-ROYCE RADIATOR, "Greek" in style since 1904. The 19th century saw a recurring tendency to impose Greek porticoes on buildings and vehicles—if possible on the "forehead" of the structure—as a central seal or sign.

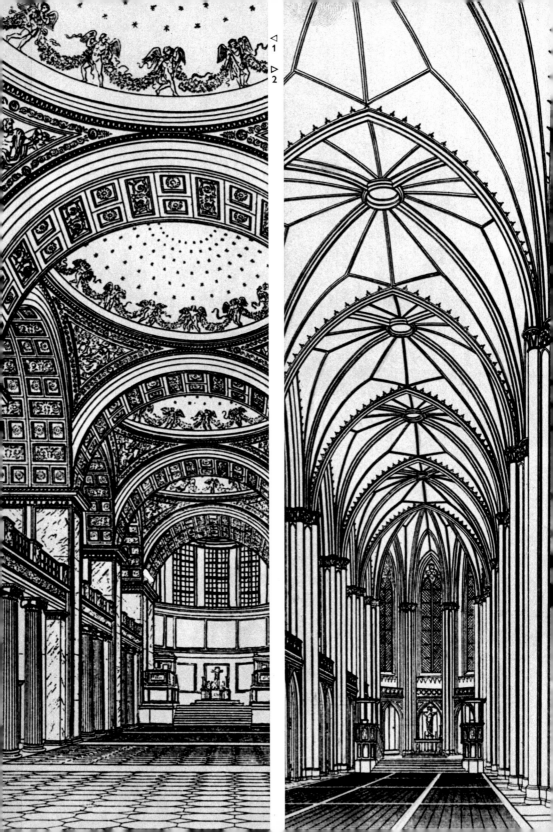

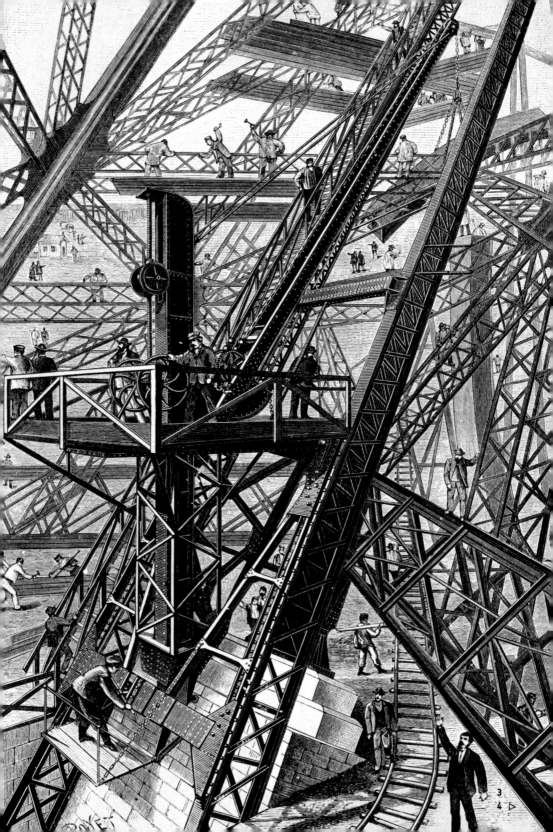

3
4 ▷

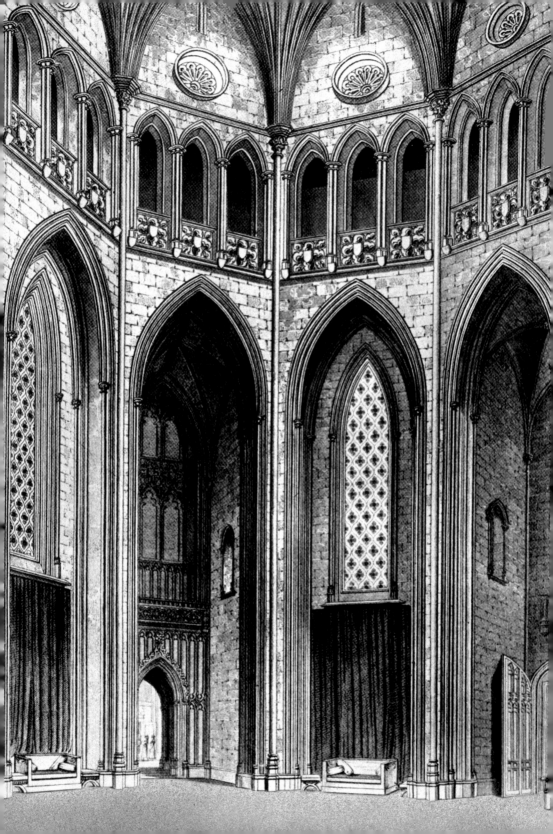

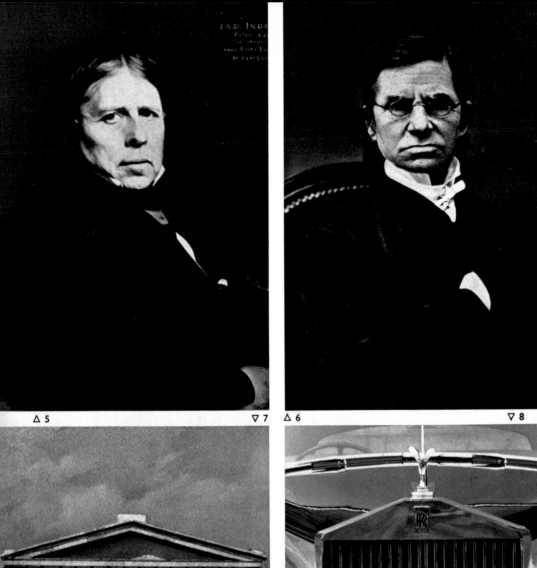

△ 5 ▽ 7 △ 6 ▽ 8

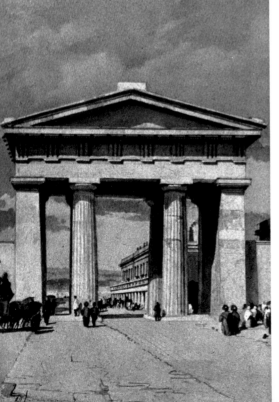

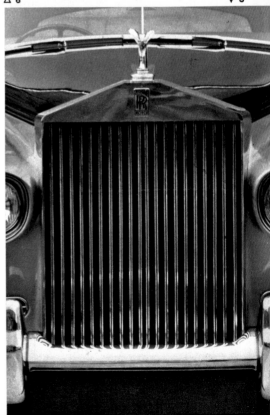

Information: The expansion of communication was carried out in the 19thcentury with almost astounding vigor, in all three dimensions—that is, in speed, breadth, and depth of information. Speed: instantaneous communication by telegram and telephone. Breadth: rapid transmission of news by newspapers, the spread of information about ethnology, biology, botany, etc., throughout the globe, as a result of accurate methods of measuring and counting. Depth: a new impetus in historical studies, which broadened to include the history of language, art, religion, etc.

Reproduction: Printing was complemented by various pictorial reproduction techniques (lithography, photography). The newspaper reproduced actuality. Equally if not more important was the "reproduction" of plants and animals: chemical fertilizers for plant growth (Justus von Liebig, 1841); the international exchange of plants, made possible by the invention of the hothouse, which canceled out climatic differences (the first center for this was Kew Gardens, London); systematic breeding of animals.

Preservation: Greater protection of health by hygienic measures was given impetus by campaigns against puerperal fever (Ignaz Philipp Semmelweis) and for compulsory smallpox innoculation (Germany, 1874). There were new methods for conserving meat, vegetables, and other foods.

Such examples could be multiplied. But it is interesting to note that in each case the spectrum of achievement ran from the "prosaic" to the "lofty": in information, from the telegram to the study of history; in reproduction and multiplication, from fertilizer to pictorial reprints; in preservation, from the soup cube to the museum—for what is a museum if not an institution for preserving important works of the past? And what are neo-Gothic and neo-Renaissance tendencies but attempts to reproduce the stylistic unity of past eras?

It is perhaps stretching a point to contrast products from such diverse levels of achievement, but it does bring out the fact that these varied products of civilization all have a common basis in method. Researchers of the 19th century in various countries developed similar methods to solve the same kinds of problems. In other words, as far as methods are concerned, 19th-century civilization evolved a very definite "style." This style—this coherence—derives from common motivations and goals. The results, by contrast, are often highly dissimilar and have no easily recognizable style.

Since we are concerned here with the stylistic history of the 19th century and not with the history of civilization, the final question must be: How and under what circumstances could this dramatic expansion of range, this unified methodology, lead to any kind of style in art?

The idea that art is something more elevated than "mere" civilization was by no means self-evident to Leonardo da Vinci, but the 19th century was preoccupied with establishing just such a hierarchy of values. For all that, as pointed out earlier, the 19th century had great difficulty with its loftier building projects or themes in painting. Cathedrals, where they were built at all, were esthetically inferior to halls, bridges, towers; madonnas and historical or philosophical subjects often resulted in turgid canvases, where still lifes, landscapes, and simple everyday scenes inspired masterpieces.

One might almost draw the paradoxical conclusion that only when a 19th-century painter dared to be "prosaic" could his work survive in the esteem of posterity. This is true of David, with his reportage on the *Death of Marat* (*108*); and it is even true of Ingres, who is less masterly when dealing with exalted themes—such as the *Apotheosis of Homer* (*115*)—than with simple subject matter, which he invests with inner significance and nobility. Above all, it is true of the Impressionists and of Toulouse-Lautrec.

Here we see a novel phenomenon—the exclusively 19th-century phenomenon of inversion of values. The provocative and oft-quoted 19th-century maxim "Better a well-painted asparagus than a badly painted madonna" (Max Liebermann) would have seemed to Raphael, Rubens, Rembrandt, and Tiepolo as incomprehensible as it was unnecessarily extreme; for artists of the 16th, 17th, and even of the 18th centuries, it would have provoked more embarrassment than amusement. But for the 19th century it concisely points up a clear and growing tendency.

Certainly the Classicists and Romantics—up to about 1830—would have had nothing but irritable scorn for Liebermann's words about the asparagus. But from the time of Courbet, at the latest, there was always a group or faction prepared to defend with conviction this inversion of the scale of values. The traditional "descending order" of themes did not disappear: In 1822 Delacroix painted *Dante and Virgil Crossing the Styx* (*112*), and a little later we have Ingres' *Apotheosis of Homer* (*115*). But, by mid-century, a picture could be called simply *The Washerwoman* (Daumier, c. 1863; *127*), *The Stonebreakers* (Courbet, 1849; *128*), or *The Gleaners* (Millet, 1857; *129*); there was no longer any claim to higher cultural pretensions, be they Christian-theological or humanistic-historicizing. The new trend was exemplified by a title like Manet's *Olympia* (1863), which is unambigu-

ously ironic, since the painting depicts not a goddess but a very common city creature — a Paris prostitute.

This descending order of themes really refers only to a kind of diagonal line through the whole field of 19th-century production; but it happens to be a line that, like a slanting vein of gold, reveals the direction of the highest success. To overstate the case, it seems to indicate, at least to 20th-century eyes, that by the second half of the century a masterpiece could arise out of the treatment of commonplace, unpretentious motifs, whereas more exalted subjects were no guarantee of artistic worth. For, particularly in France after 1850, the greatest painters were not friends of theologians, humanists, and historians; on the contrary, they were in the opposite camp, among doctors, engineers, and inventors. This is enough to show that two scales of value operated in the 19th century, embodying quite different directions of endeavor: the humanists' and theologians' idealistic hierarchy of values, and the pragmatic one of the scientists and technologists.

The existence of these separate scales of value for 19th-century artists—from musicians and poets to painters and architects—represented both a challenge and a dangerous pull in two directions. As a whole, fine arts give a faithful picture of this polarization, for almost every work that can be assigned to one scale of values has its counterpart in the other: Renoir's *La Grenouillère* (*143*) and Böcklin's profoundly idealistic *Isle of the Dead* (*134*); Monet's *Gare St-Lazare* (*138*), which was preceded a decade before by Gleyre's *Pentheus Pursued by the Maenads* (*114*).

The same polarization can be seen in architecture: for every "bare" structure (station concourse, exhibition hall, lattice tower), one can point to a piece of "clad" architecture from the same period. Examples are the "bare" Crystal Palace by Paxton (*33, 37*) and the "clad" Federal Polytechnic, Zurich, by Semper (*34*), both erected in the 1850s. In the 1870s and 1880s, one can point to the "bare" Eiffel Tower (*3, 32*) and the "clad" Palace of Justice in Brussels by Poelaert (*59*). Again this confirms the assertion that there is hardly any consistent unity of style within any given period of the century. Every generation has at least two prominent stylistic areas, and, if examined more closely, these styles are seen to rest on idealistic and pragmatic convictions respectively.

It is impossible to begin asking any questions about the stylistic history of such a vast and productive era as the 19th century without first defining some relationships. The easiest way to do this is to make use of accepted terms and categories. These concepts may not be very meaningful, but since they have stood the test of time, they at least have the virtue of showing that the relationships have been noted by succeeding generations with differing criteria. Such concepts, still used to designate areas of style, include Classicism, Realism, Symbolism, and so forth.

In any one generation, at least two of these strains are present, and, on closer inspection, it will be seen that, for the most part, the idealistic and the pragmatic operate simultaneously. The painting of the 19th century clearly exhibits the following polarizations:

| Classicism | – | Romanticism | Pre-Raphaelitism | – | Impressionism |
| Idealism | – | Realism | Symbolism | – | Expressionism |

The two scales of value are well illustrated by the first pair of terms, for instance in the tendency of Classical art to see the essence of its being in "height" (sublime subject matter), while Romanticism is inclined to "depth." (A further pair of opposites might be clarity and coolness as against darkness and warmth.)

Architecture shows a similar division, which I have attempted to summarize as architecture by architects, in contrast to architecture by engineers and gardeners. Sculpture is not so consistently important in the period. Here, too, however, familiar concepts play an important role, including Classicism, Romanticism, Realism, and Impressionism. In all areas, these designations represent something like a "diagonal line," cutting at varying levels across a field of production that, at the beginning, is quite clearly idealistic, but by the *fin de siècle* is just as clearly pragmatic.

It is striking that in this century of changes and contrasts one motif persistently occurs, and in the most diverse places: the Greek temple portico. Influences of the 18th century were still at work perhaps, when, from the competition of 1806, Napoleon chose a temple-front design for the church of the Madeleine in Paris. It is more difficult to understand why the same idea should recommend itself to the designers of a completely new kind of building—the railroad station. Euston Station in London (1835–39) was graced with a Greek portico, complete with cornice (7), and this motif even made an appearance in the development of the automobile seventy years later: the radiator grill of the Rolls-Royce (8) has the familiar portico shape, this time miniaturized and executed in metal (1904). This might be interpreted merely as a survival of the Classicist tradition, but the argument does not seem entirely convincing. Is it not perhaps a sign that the expansion of range in the 19th century had reinforced an old, secret desire—the desire for the former natural range of civilization, which found its finest formulation in the Greek temple? Every new, ever-more-commonplace building or structure—station, automobile—is stamped somewhere, most often on the "forehead" (entrance arch, radiator grill), with the "seal" of the temple front. A secret sign? A ritual? Above all, it is a yearning for the past, more significant with every step away from the former natural range of man, the lost paradise.

At the same time, the Greek temple cannot truly be recaptured or reconstructed any more than the Gothic church, with its pointed arches, spires, and pinnacles. Why? Because

this reconstruction can never be anything but an old form realized with other methods. For example, the details of Schinkel's neo-Gothic Werder Church (2) may be astonishingly accurate from the historian's point of view, but materials, supply, transport, labor, craft techniques, and so forth, were selected and organized in a completely different way from that of the Middle Ages or the 4th century B.C. That is to say, when the 19th century built or painted or drew in the Classical Greek or the neo-Gothic modes, it generated the manner without the means. This is the insurmountable barrier for all those who wish to copy history.

But wherever the means—the method—are in keeping with the manner in the 19th century, genuine areas of style can be found. In architecture, this is strikingly true of iron structures such as halls, bridges, and towers; their unity of construction represents a real and new kind of harmony. It is equally true in painting, as exemplified by the Impressionists, whose application of scientific knowledge acquired from optics to artistic ends represents a unity of method that gave rise to a true and original style.

ARCHITECTURE

In the Introduction, we saw that in the 19th century not only style itself but the very concept of style was insecure. Not everyone involved in building, however, took part in the conscious search for style; it was chiefly the architects, in the narrowest sense of the word, who were obsessed by it. Engineers were apparently not burdened with this concern; rather, they concentrated on technical mastery—width of span, stress capacity, the quantity of materials used in a structure—not on style.

In differentiating the engineer from the architect, it is easy to overlook a third contributor to 19th-century building: the gardener. In this book, we shall consider architecture as the product of three separate professions: architecture by the architect, architecture by the gardener, and architecture by the engineer.

Architecture by the Architect

It is impossible to understand architecture at the beginning of the century without reference to the events that took place in France between 1750 and 1800. As a result of the French Revolution and Napoleon's Empire, France acquired unique prominence as a center of influence. It was French prestige, generated first by the Revolution, then by Napoleon, that carried the ideas of Revolutionary architecture through Europe, from Dublin to Naples, from Copenhagen to Athens and St. Petersburg, and to America as well.

The outstanding figures among architects of the Revolutionary period are Étienne-Louis Boullée (1728–99) and Claude-Nicolas Ledoux (1736–1806). Their most imaginative architectural visions were conceived shortly before the Revolution—between about 1775 and 1790. We find here one of the rare instances of architectural plans being bolder and more avant-garde than the works of contemporary painters. These architects invented "utopias" —projects they themselves never expected to see executed. For example, when Boullée in 1784 designed a cenotaph (9, 10) for Sir Isaac Newton (dead for more than fifty years, but

9, 10 ÉTIENNE-LOUIS BOULLÉE (1728–99), SKETCH AND CROSS SECTION OF A DESIGN FOR A CENOTAPH FOR SIR ISAAC NEWTON. 1784. Never executed. Boullée drew two versions of this memorial, which differ particularly in their treatment of the interior. Shown here is the "night" version, with a planetarium arching above the sarcophagus; the "stars" are lit through tiny channels piercing the upper half of the sphere. In both versions the interior forms a perfect sphere, which, on the outside, is partially concealed by the podium. The individual terraces are connected by flights of steps. The effectiveness of the design lies in the powerful simplicity of its component elements —sphere and cylinder—and in its gigantic dimensions. Based on a module of 1.75 meters (that is, a measurement relating to human size), the crown of the dome is 147.2 meters above ground level, and the interior of the sphere, or drum, has a diameter of 67.1 meters. With such dimensions, the project made demands far beyond the building technology of the day. (The Pantheon in Rome, by comparison, measures 43.4 meters at the drum.)

11 ÉTIENNE-LOUIS BOULLÉE, DESIGN FOR A NECROPOLIS. Undated. Never built. Again, Boullée used a module of 1.75 meters, and again, the dimensions involved are gigantic. The whole site (with the exception of the mountain temple) rises some 145 meters above the river, and the main temple is 48 meters high. In the design 1,980 meters of river bank are shown. The dome of the main temple, deeply sunken into the colonnades encircling it, resembles a planet rising or setting. By virtue of the fact that the mountain temple lies precisely on the main axis of the site, the landscape itself acquires architectural quality.

12 CLAUDE-NICOLAS LEDOUX (1736–1806), BIRD'S-EYE VIEW OF THE SALTWORKS CITY, CHAUX. c. 1780. Partly built. The plan for this town in the neighborhood of Besançon, designed entirely to meet the needs of the salt industry, presents an abstract, geometrical pattern. The central point of the concentric layout is the house of the director, flanked by the saltworks buildings. Beyond the ring of workers' houses that surrounds the center lie the public buildings. Ledoux gradually elaborated the plans for Chaux into a scheme for an ideal city; after 1804 he collected all the architectural designs involved in this project (and much other work besides) in his great town-planning work, *L'Architecture considérée sous le rapport de l'art, des moeurs et de la législation.* The Chaux site shows a very clear disregard for perspective. At human eye-level it is impossible to gain any overall view of the site; only from the air can the shape of the town be discerned, since it is divided into separate segments that are related to each other only in terms of a strict geometrical pattern. Accentuated points in the plan indicate new social assumptions: in place of the ruler's seat or the church we find the bureaucrat's residence; the factory yard replaces the park or the marketplace; it is not the stately homes of the aristocracy but workers' houses that occupy the prime positions in the plan.

13 CLAUDE-NICOLAS LEDOUX, DESIGN FOR THE CEMETERY AT CHAUX. Before 1789. Never executed. Significantly, the layout of the cemetery is organized in the same way as the plan for the town. The necropolis is meant to be an evocation and a symbol. The central area—it is no accident that it takes the form of a sphere—is not accessible; one can, however, look into it, but only from the main chambers of the three-storied "catacomb." The sphere and grave passages receive light from above. The finished building should be imagined with the sphere half-buried in the earth. This picture also comes from *L'Architecture considérée ...*

14, 15 JEAN-NICOLAS-LOUIS DURAND (1760–1834), ARCHITECTONIC COMPOSITION-SKETCHES. From *Précis des leçons d'architecture*, 1802–5. These two pages from his architect's manual show what Durand meant by composition: combinations generated from a basic geometrical form. In the upper plate (*14*), each line of the schematic diagram represents a wing of a building, With an increasingly complex distribution of architectural elements, we move from the enclosed court with uniform sides to H-shapes and corner-pavilion formations, and, finally, to a commanding central structure flanked by potentially autonomous units. All of these layouts strike us as familiar; however, no exact antecedents or influences can be pinpointed.

The lower plate (*15*) is concerned with the integration of natural elements—in this case, water—into architectural compositions. Numerous treatments of fountains are represented here, from the most simple setting to the gushing and cascading of multiple jets of water, as well as, of course, the pump and the reservoir. Durand's plates are like comprehensive catalogues: graphic refinements are subordinated to systematic information.

16 WILLIAM KENT (1685–1748), GARDENS AT CHISWICK HOUSE. Estate of Lord Burlington, near London. Early 1730s. One of the earliest of the classical English gardens. There is a fundamental departure from the French-Italian axis layout. Instead of axes and diagonal lines, we find free, often winding paths that lead to vistas, springs, grottoes, and memorial temples.

17 ROBERT ADAM (1728–92), RECONSTRUCTION OF THE SOUTH FRONT OF DIOCLETIAN'S PALACE, SPALATO. From his publication *The Ruins of the Palace of the Emperor Diocletian at Spalato*, 1764. At the foot of the page appears a painstakingly careful impression of the façade "as it now remains." Above, the architect-archeologist displays a reconstructed version. Crucial parts of the façade—for instance, the central pavilion—have not survived. The reconstruction arrived at by Adam is thus a mixture of the careful reproduction of archeological fragments and an imaginative vision of the building's former appearance.

18 ROBERT AND JAMES (1730–94) ADAM, ADELPHI TERRACE, LONDON. 1768–72. Demolished 1936. The base or podium area of this luxurious series of town dwellings is reserved for storehouses and shops, while the residential block stands at a dignified distance from the noise and traffic of the Thames. The row of houses presents to the world a single, palace-like façade, sparingly but elegantly decorated.

19 JOHN NASH (1752–1835) AND JAMES THOMSON (1800–1883), CUMBERLAND TERRACE, REGENT'S PARK, LONDON. 1826–27. The ground-level business area is suppressed in this building; the restrained, barely sculptured façade has become a fashionable palace, its brilliant whiteness contrasting with the lush green of the park opposite. The building is divided into separate, independent houses, articulated by pairs of Ionic columns.

20 SIR JOHN SOANE (1753–1837), PLAN FOR THE ARCHITECT'S HOUSE, LONDON. 1812. Loggias and balconies project from the "true" façade of brick, creating a column of space and distinguishing the architect's house from its neighbors. The elements of this superimposed frontal section are thin and elongated, almost giving the appearance of cardboard.

21 SIR JOHN SOANE, ENTRANCE TO THE DULWICH MUSEUM. 1811–14. This entrance hall is known as the "mausoleum." (In fact, the founder, Sir Francis Bourgeois, and two friends are buried there.) The decoration of urns and sarcophagi, as well as the ground plan, which is shaped like a Greek cross, are reminiscent of a burial monument. Only the podium and roof areas are faced; the rest of the building has been left in its "natural" state.

22 SIR JOHN SOANE, BREAKFAST ROOM IN THE ARCHITECT'S HOUSE, LONDON. 1812. The supports of the tent-like domes have neither capitals nor shafts; they are like the veins of a leaf that just happen to touch the ground. Apart from one or two ornamental features, there are few allusions to historical styles: Although Soane was extraordinarily well versed in history, especially ancient history, in his own architecture he used a minimum of historical quotation. Compare *23*.

23 SIR JOHN SOANE, OLD DIVIDEND OFFICE, BANK OF ENGLAND, LONDON. 1818–23. Demolished 1927. The impression of a taut skin or tent is stronger in the interior than from the outside of the building.

24 FRIEDRICH GILLY (1772–1800), DESIGN FOR THE BERLIN THEATER. 1798. Half-cylindrical rooms for the public project from the solid square block of the auditorium. They are entered through a simple portico with Doric columns. Sparing use of ornamentation and stylistic quotation bring this project close to the work of the French Revolutionary architects. Gilly knew Ledoux and others personally, and during a stay in France he visited their buildings.

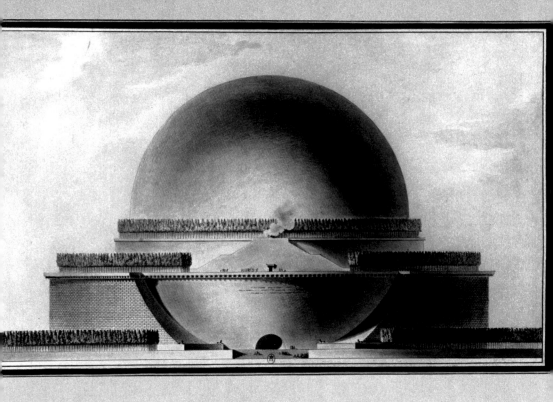

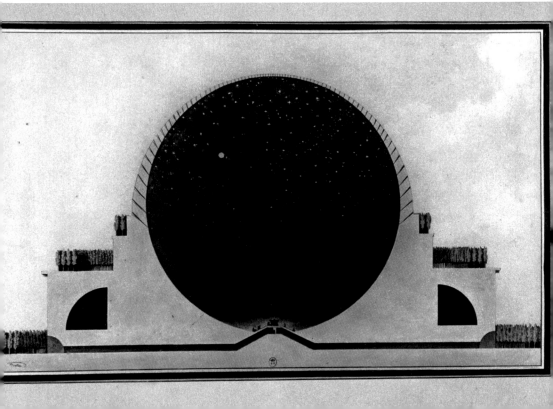

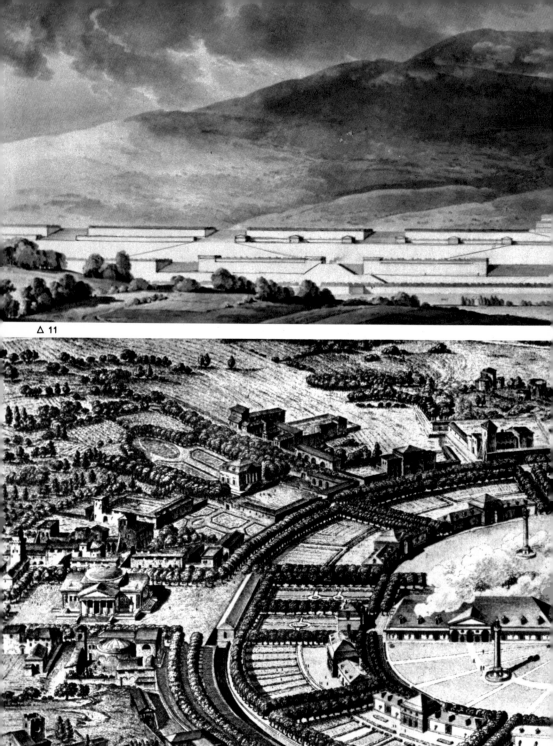

△ 11

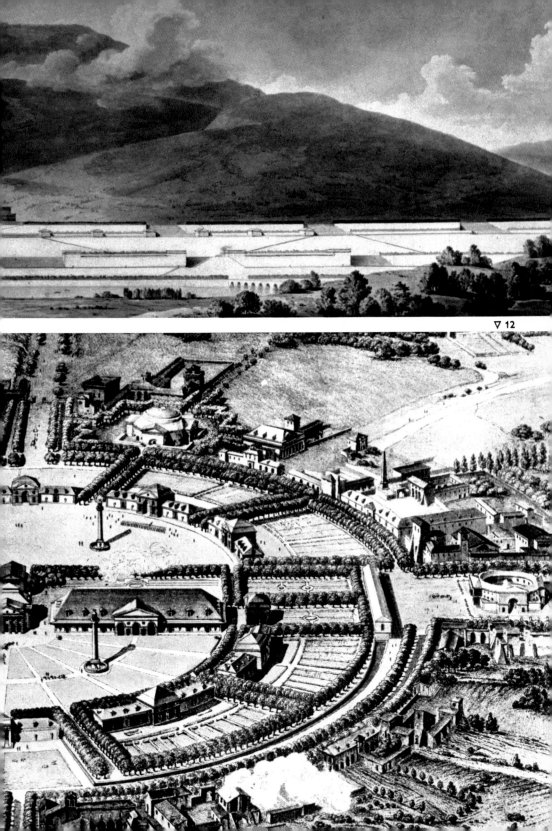

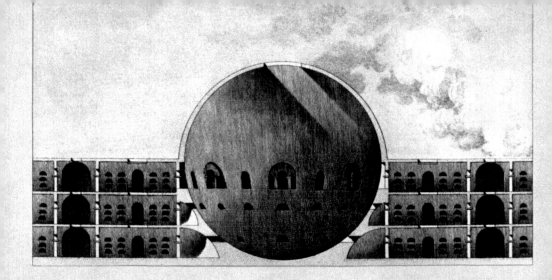

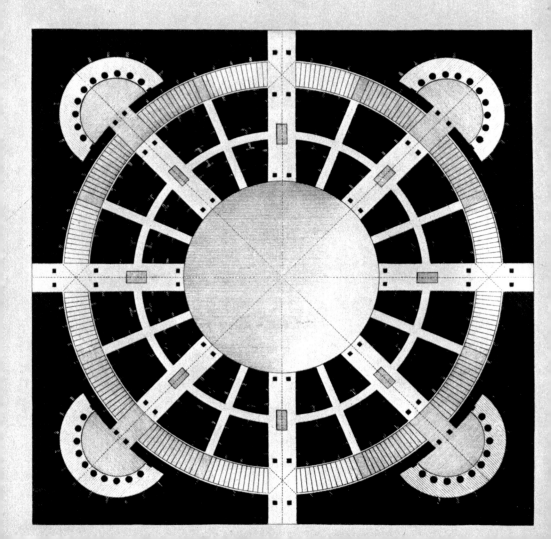

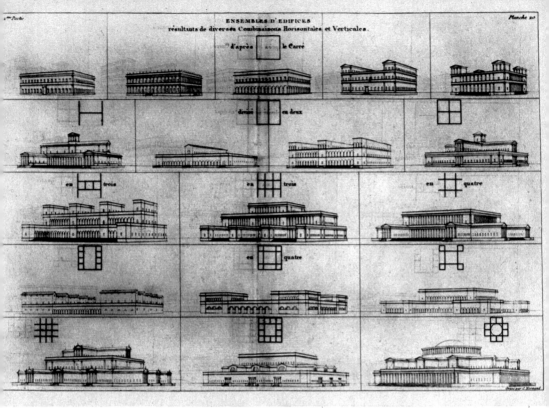

ENSEMBLES D'EDIFICES
résultants de diverses Combinaisons Horisontales et Verticales.

d'après le Carré

Gravé par C. Normand.

◁ 13 △ 14 ▽ 15

EMPLOI DES OBJETS DE LA NATURE DANS LA COMPOSITION DES EDIFICES.

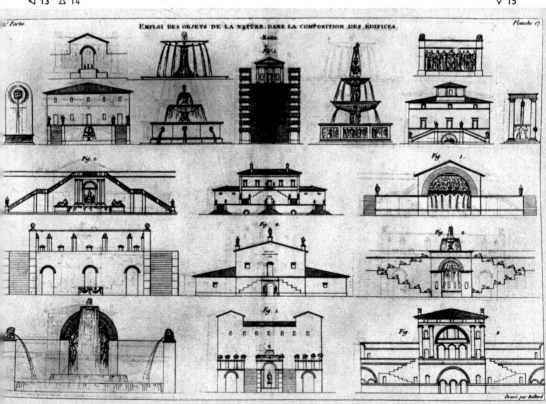

Gravé par Baltard.

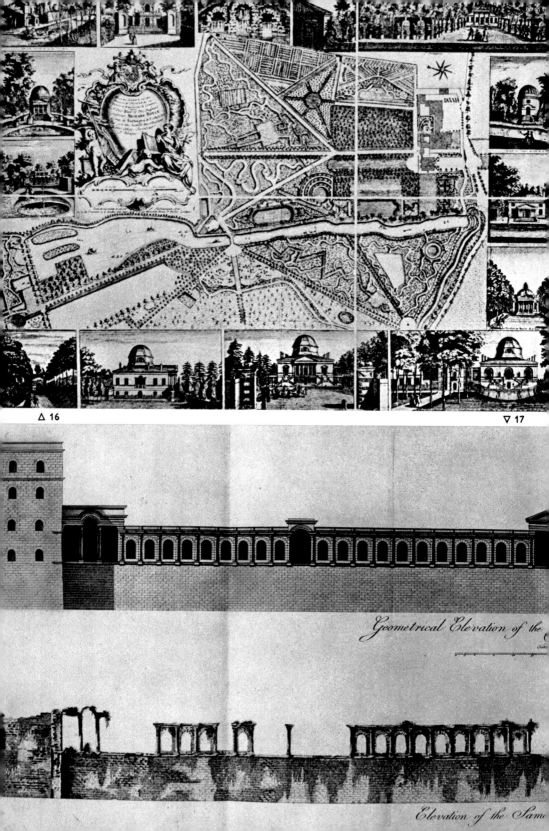

△ 16

▽ 17

Geometrical Elevation of the

Elevation of the Same

△ 18

△ 19

Porticus or South Wall of the Palace

s it now Remains

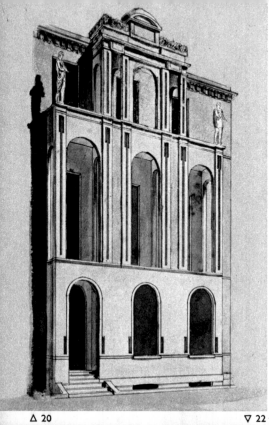

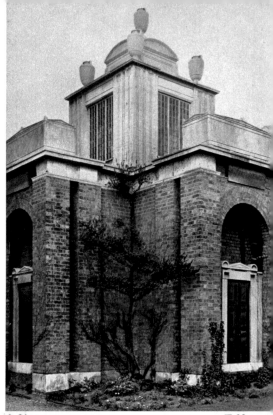

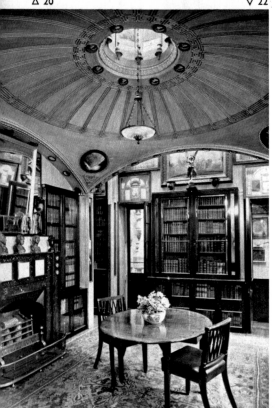

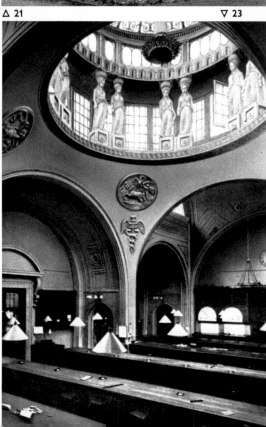

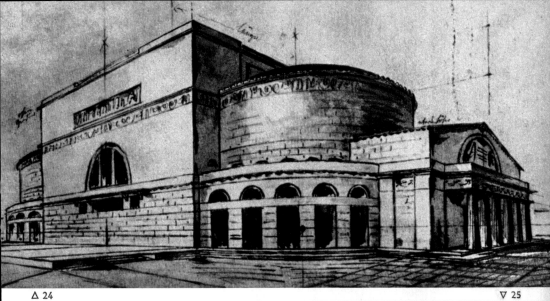

△ 24

▽ 25

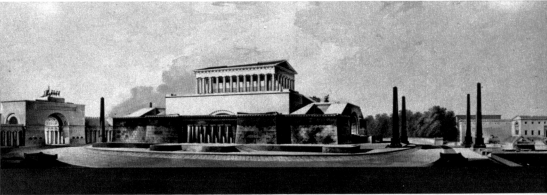

▽ 26

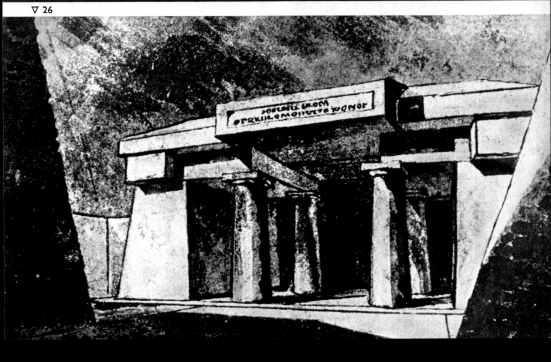

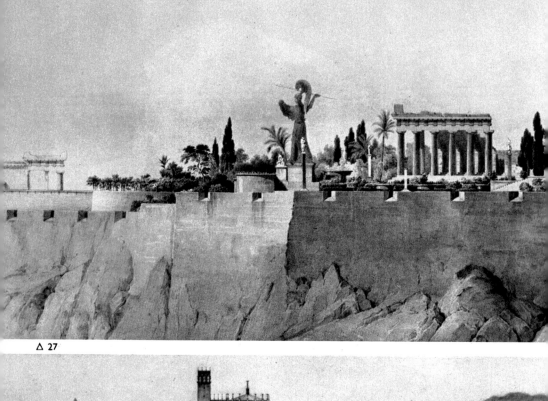

△ 27

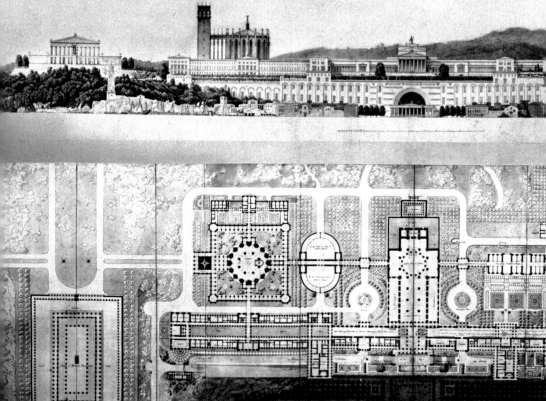

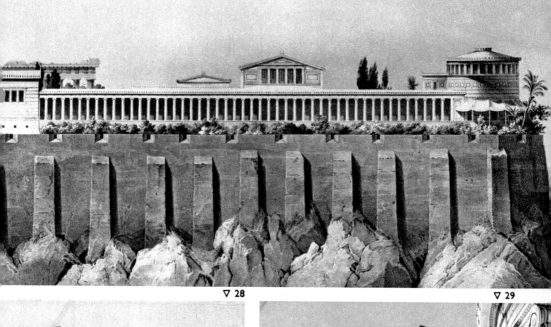

▽ 28

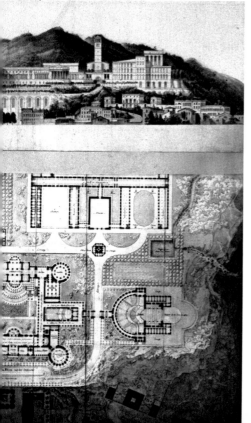

▽ 29

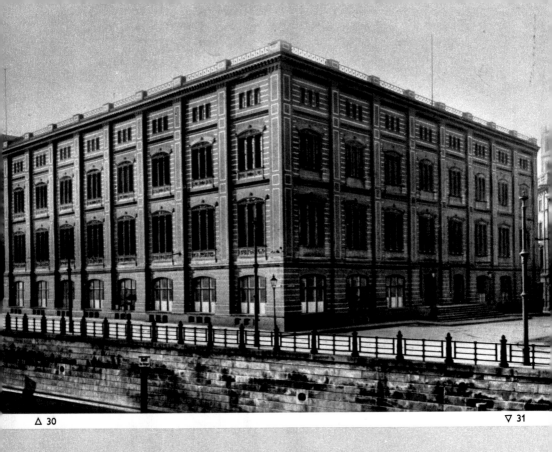

only just then becoming world famous), he was aware that the chance of such a plan being carried out was remote. Architects have always indulged in fantasy projects, but in the years immediately before the Revolution, fantastical conceptions were regularly committed to paper: this is how one "should be able" to build; such monuments "should be possible," if mankind were to be educated as Boullée and his generation—a generation that included Jean-Jacques Rousseau and Immanuel Kant—desired.

25 FRIEDRICH GILLY, DESIGN FOR A MONUMENT TO FREDERICK THE GREAT. 1797. German architects of Gilly's generation were very much interested in architectural monuments. Gilly's layout resembles his pupil Schinkel's later design for a castle in the Crimea (29): Gleaming above a grotto, a Greek temple is seen as the essence of purity and virtue.

26 FRIEDRICH GILLY, DESIGN FOR AN ENTRANCE ARCH. Undated. Not only spatial elements (24) but also structural components are outlined and combined in an economical and unadorned manner. The system of weights and supports, with its massive proportions and squat Doric columns, evokes the timeless and the eternal.

27 KARL FRIEDRICH SCHINKEL, DESIGN FOR THE GREEK ROYAL RESIDENCE ON THE ACROPOLIS, ATHENS. 1834. Schinkel-Museum, Berlin. On the north side are the king's apartments, the private garden, and the audience chamber, which were to be polychrome, following the latest discoveries about antiquity. In this project the Parthenon is retained as a ruin in the foreground. A new Athena (Promachos—"fighter"), replacing a giant statue by Phidias that once stood between the Propylaea and the Erechtheum, and had been lost in antiquity, was to be the crowning glory of the site. This Acropolis design shows the need felt by the architect to display his scholarship. Schinkel is completely up to date with the latest findings of archeology. Although he knew the significance of temple layout, he would not shrink from building over the sacred ancient site for the sake of new prestige architecture.

28 KARL FRIEDRICH SCHINKEL, DESIGN FOR THE IDEAL PRINCELY RESIDENCE. 1835. Schinkel-Museum, Berlin. The ground plan shows Schinkel's virtuoso handling of symmetrical relationships and axes. The plan consists of the imposition of one axial system—that of the structures—on another—that of the passages and paths. One gives way to the other according to the relative importance of access routes or structural elements.

29 KARL FRIEDRICH SCHINKEL, PROJECT FOR ORIANDA CASTLE IN THE CRIMEA. 1838. Schinkel-Museum, Berlin. Schinkel planned this enchanted country palace for the tsarina, the sister of his patron Frederick William IV of Prussia. In the middle of the courtyard, which is formed by wings containing the royal suites, there is a museum for South Russian sculpture, conceived as a grotto with a tree-dotted garden above it. Overlooking the entire site is a Classical temple, which commands a fine view.

30 KARL FRIEDRICH SCHINKEL, SCHOOL OF ARCHITECTURE, BERLIN. 1832–35. Erected on a chequered ground plan, this project could almost be an illustration to Durand's *Précis des leçons...* (14, 15). The two middle stories, carried out in brick, are composed of cube-shaped rooms and are exactly alike except for fine differences in the ornamentation of the façade. The ground and attic floors are half the height of the others. The exterior facings reflect the interior structure. Because of the uniformity of the façades, there is no axial pull.

31 KARL FRIEDRICH SCHINKEL, PLAYHOUSE, BERLIN. 1819–21. The body of the building can be seen either as a composition of individual cubes or as a structure formed by the interlocking of simple geometric blocks. The windows are unadorned, without balustrades or moldings, and are grouped in uninterrupted series. Though the emphasis of the building is basically on simplicity, it is furnished with a richly decorated pillared portico, which, with the pediment of the main auditorium that projects above, produces the appropriate air of dignity.

With his spherical structure, Boullée evokes the night sky; the effect of starlight is counterfeited "naturally" by tiny channels that allow light into the dark interior. He also attempted to demonstrate how the earth looked in its original state, before the Fall from Grace (the planet's rotation): it was then a perfect sphere. (Through rotation, as Newton and contemporary physicists had demonstrated, the earth had become slightly flattened.) Another extravagant project that preoccupied Boullée was a necropolis, or burial ground (11), set out in vast terraces between a river and a mountain. Here too symbolism is given more importance than functionalism: although the plan has the practical function of a cemetery, it is more significant as the architectural expression of the meaning of death. (The architect's chief tool here is silence—the bare, mute wall without doors or windows.)

Ledoux countered Boullée's necropolis with a plan for a model town for the living, an important work whose influence is still felt today (12). The French king commissioned him to build Chaux, an "ideal city" near Besançon around the royal saltworks at Arc-et-Senans, to contain both working and living quarters for the early industrial society. Ledoux continued to work eagerly on this project long after the commission had been canceled because of political troubles. For him, as for Boullée, "what ought to be" was just as real as what, by a greater or lesser degree of historical accident, could actually be realized in bricks and mortar. The cemetery of this model town (13) adopts Boullée's spherical motif, here used as an eerie hollow sculpture within a forbidden area.

Of all Boullée's and Ledoux's students, the one who, paradoxically, made the greatest impact on Europe built little himself: Jean-Nicolas-Louis Durand (1760–1834). He was a professor of architecture at the newly established École Polytechnique in Paris and had the gift of translating into rational and practical terms the grandiose and imaginative ideas of his teachers. Durand transposed the fantastic spheres, pyramids, and cubes that had so profoundly and unrealistically fascinated his master Boullée and others into useful geometric or three-dimensional forms. His designs (14) demonstrate how he derived a large number of variations from combinations of the most basic elements. This "combinatory" approach was propagated and practiced throughout Europe by Durand's students. Durand himself built only one house, but his numerous students put nearly all his suggestions (14, 15) into practice in the capitals of Europe. From the great but unbuildable ideas of revolutionary architecture, Durand evolved a kind of unit-building system, which allowed many variations on a given theme and the possibility of selecting the most economical version. Thus Durand's great role was that of intermediary, and his early impact was felt until the middle of the century.

Next to France, England had the most decisive influence on 19th-century architecture (16–23). Which country was in fact more influential is an open question and one that

essentially cannot be resolved, because we are talking about influences on different levels. France was the leader in the new organization of form and space, while England contributed a new understanding of nature and of antiquity. The new feeling for nature led, during the 1730s, to the so-called English garden (*16*), in contrast to the Italian-French style, so well illustrated at Versailles, with its dominating central axis and ordered rows of plants. The English garden had no such axes; it appeared unplanned, with unexpected paths and vistas through hills and woods that are dotted with little pavilions—now a Gothic ruin, now a Greek temple, now a Chinese pagoda. The English garden was nothing less than a "total environment," representing not a change in building style but in ambiance, and this was a true innovation with wide repercussions, particularly for the architecture of the first half of the century.

The new understanding of antiquity in Britain owed much to the English enthusiasm for Palladio, whose typically Renaissance ability to combine the roles of architect and archeologist was admired and emulated by Englishmen between 1750 and 1850. Robert Adam (1728–92), for example, surveyed and reconstructed the Palace of Diocletian at Spalato (now Split, Yugoslavia; *17*), applying modern methods of research. He made an astonishly precise distinction between extant findings (lower drawing) and possible reconstructed areas (top drawing). As a historian, Adam worked in a scholarly and not a visionary fashion, and this tendency was primarily an English one. Back in England, he applied to new building the historical knowledge he gained from his on-the-spot study of antiquity. Adam's superb town houses in London (such as the Adelphi Terrace, *18*) are examples of the practical application of ancient models—that is, of Classicism—based not on subjective vision but on archeological evidence.

Classicism

It is by no means obvious why a new taste for "noble" architecture should arise after the French Revolution, but it did. The 19th-century version of Classicism was formulated by the English and, sociologically, was supported less by the aristocracy than by the new leading class of industry and colonialism. John Nash (1752–1835) gave this dynamic, humanistically inclined new upper middle class its representative architecture (Cumberland Terrace, London, *19*), a model of cool and refined elegance that we today consider as typically English. It was soon carried from palatial London dwellings to hotels across half the world, for early tourist facilities bore the stamp of the English ideal of nobility. Whether they were erected on the Nile or on a Swiss lake, these early hotels were all inspired directly or indirectly by English Classicism.

32 ALEXANDRE-GUSTAVE EIFFEL, TOWER. World's Fair, Paris. 1889. Contemporary photograph. Without reference to any famous historical precedents (such as, for example, the Lighthouse of Alexandria, one of the seven wonders of the ancient world), and thinking purely in engineering terms, Eiffel and his colleague Maurice Koechlin (1856–1946) erected what has been known ever since as the Eiffel Tower. At the time, it was the 300-meter-high symbol of the Paris World's Fair. Only at points with a practical function (balconies, elevator platforms, and so forth) do "artistic" forms occur within the pure engineering form. In matters of detail, even Eiffel obviously feared that the beholder would be offended by pure structure without any ennobling artistic features. But, in general, he strictly followed structural principles.

33 SIR JOSEPH PAXTON (1803–65), DESIGN FOR CRYSTAL PALACE. Great Exhibition, London. 1851. Design without the later transverse arm. The dimensions of Paxton's glass palace are technically more daring than in large modern projects, which benefit from prefabrication and highly organized building sites. Apart from the limitation of making the length—1,851 feet—correspond to the date of the exhibition, the span and width of the hall depended only on how large the glass plates that form the outer fabric of the structure could be made. To achieve the shortest possible building time, special assembly techniques and working procedures were evolved and applied. Only the entrances, as areas of particular visual intensity, are treated "artistically."

34 GOTTFRIED SEMPER (1803–79), FEDERAL POLYTECHNIC, ZURICH. 1858–64. Watercolor view of the main façade. This structure, which appears to be conventionally Renaissance in style, is actually a combination of four separate buildings that house the administration of the Polytechnic, the Cantonal University of Zurich, the collections of both establishments, and the lecture rooms and studios of the Institute. A museum with plaster casts of Classical sculptures connects the administration buildings and those containing the collections. The façade consists of two strata: In the projecting central section, a large Classical colonnade, in front of the tall arched windows of the main hall, is supported by a rustic base, very heavy at ground level, more lightly treated in the upper section, which is visually anchored to the ground by steps and stone benches; the real structure, however, is the solid block that extends to left and right of the highly ornate central projection. The architect is making the point that the Giant Order, while decoratively appropriate to the project in hand, is not a structural component of the building.

35 HOLBEIN ROOM, STRAWBERRY HILL, TWICKENHAM, ENGLAND. House of Horace Walpole. Converted to Gothic by various architects between 1750 and 1770. The interior was used for experiments in form to a greater extent than in the building as a whole. Climatic and structural restrictions have been largely ignored as elements of the Gothic style are detached from their original context and put to new uses: tracery becomes a screen, pinnacles decorate a fireplace. The whole room thereby unmistakably bears the stamp of its time; we are not supposed to feel that it could possibly be a product of the late Middle Ages. The house attracted a large number of sightseers and helped spread a taste for Gothic in England.

36 KARL JONAS MYLIUS (1839–83) AND ALFRED FRIEDRICH BLUNTSCHLI (1842–1930), HALL IN HOLZHAUSEN CASTLE NEAR FRANKFURT. 1874. In keeping with the spirit of the Wilhelminian Empire and the age of the Iron Chancellor Bismarck, the hall is decorated in the baronial style. Frankish motifs are combined with the modern conveniences of service lifts and steam heating. Where the structure in Semper's buildings is visibly articulated just below the surface, that in his pupil's work is camouflaged to the point of unrecognizability.

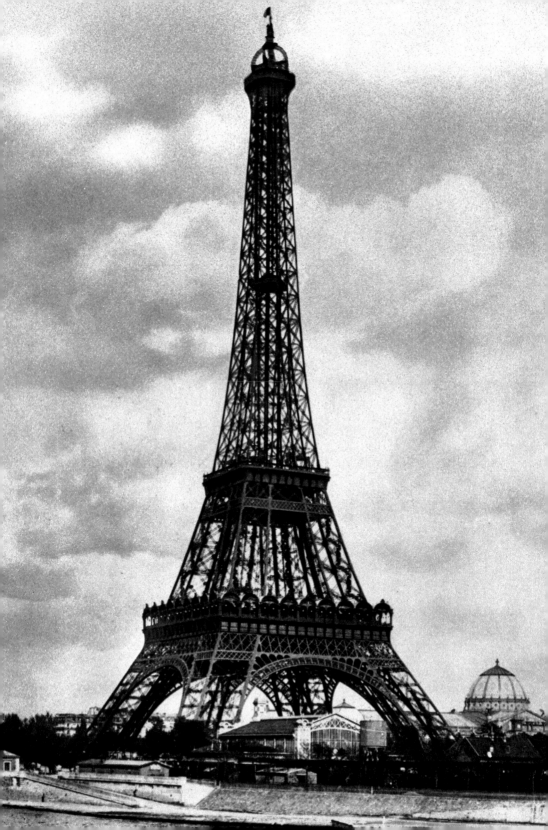

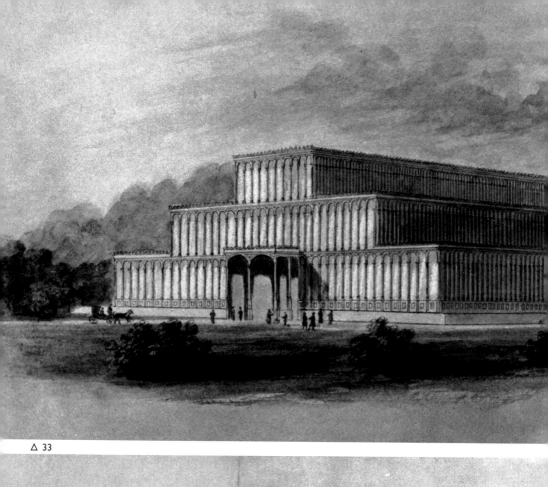

△ 33

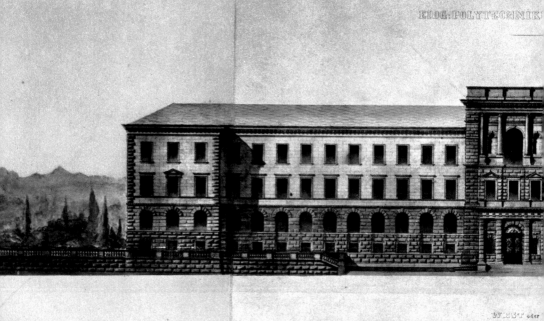

EIDG. POLYTECHNIK

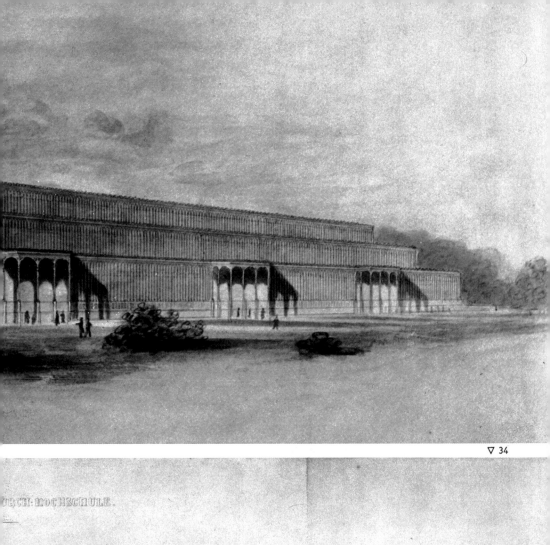

▽ 34

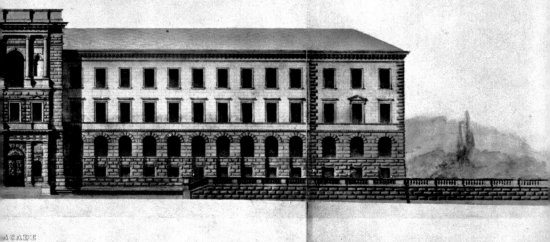

URCH: HOCHSCHULE.

ACADE

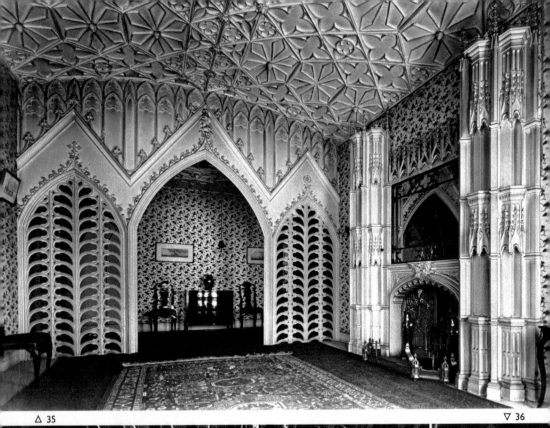

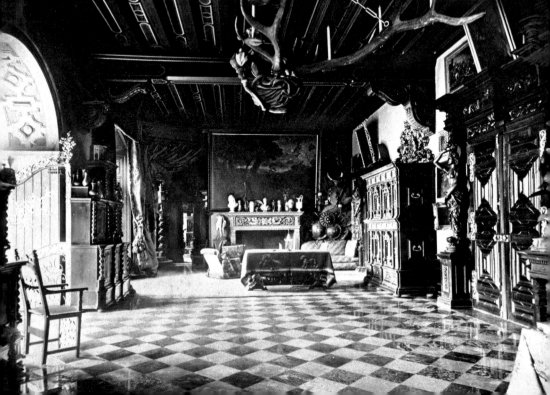

A modernist counterpart to the conservative Nash within the sphere of Classicism is his contemporary Sir John Soane (1753–1837). Nash strove for the utmost correctness in his Classicism; Soane, by contrast, was one of the first to attempt to escape from rigid rules, from iron conformity, and to invent forms that were not imposed by the limitations of Doric, Ionic, and so forth (20–23). There is no contradiction in the fact that, through his travels, Soane knew antiquity better than Nash—quite the opposite, for Soane seems to be one of the first explorers of the ancient world to realize that the true admirer of antiquity should not simply imitate it. He must prove his admiration by new, independent achievements, aware that two widely separated eras cannot truly be reconciled. Soane's own house (20, 22), his museum in Dulwich (21), and his Bank of England (23), though Classical in style, are strikingly free of Classical detail. In this, Soane is a pioneer.

Classicism in Germany in the age of Goethe was influenced by developments in France and England. But an increasingly independent use of these borrowings led finally to something that might be called scholastic Classicism, although this risks sounding redundant, for the concept of Classicism already contains the presupposition of scholarship. It was Germany that responded most seriously, even solemnly, to the clarion call of Classical education. So it is that the leading German architect of the period, Karl Friedrich Schinkel (1781–1841), worked as a scholar and for scholars. He owed much to his teacher, Friedrich Gilly (1772–1800), whose untimely death prevented him from producing more than a few highly remarkable designs (24–26). If Gilly had been granted a full span of years, German, and indeed European, architecture would surely have taken a different turn. This can be adduced from his design for the Berlin Theater (24), in which he united the geometric elements of cube, cylinder, and prism, not only effectively, but functionally. His design for a monument to Frederick the Great (25) underscores the impression that, in the series of utopian monumental designs—especially those of Boullée—that were the culmination of Revolutionary architecture, Gilly's is the last great contribution.

Schinkel was able to work on and to some extent execute what, in Gilly's short lifetime, could be no more than a vision. Schinkel's great projects are a long way from the utopianism of Boullée and Ledoux, although he did propose the construction of a royal residence on the Acropolis of Athens (27), a notion that appears today somewhat abstruse. His model designs for a prince's residence (28) and a castle for the tsarina at Orianda, on the Black Sea (29), contain important ideas: a split-level site, emphasis on the view from the building, the close connection of landscape and architecture. Among Schinkel's Berlin undertakings, the school of architecture (30) and the playhouse (31), in particular, have enhanced his reputation. Excellent organization, clear arrangement, and a controlled sense of grandeur are outstanding features of his work.

Architecture By the Engineer and the Gardener

As late as the Baroque period, engineers and gardeners were subordinate to the architect, though it might appear to us that their achievements rival or even surpass in importance the sumptuous buildings for which they were a setting (for example, the gardens of the château of Vaux-le-Vicomte or of the palace of Versailles). In the 19th century the specialists came to be considered on a more separate and more equal footing.

Moreover, a new kind of building project arose, which gave both engineer and gardener unique new opportunities: the short-term structure, particularly architecture for the international fairs. The London Great Exhibition of 1851 brought fame to the gardener Sir Joseph Paxton (1803–65), as did the Paris Fair of 1889 to the engineer Alexandre-Gustave Eiffel (1832–1923); neither, however, had the illusion of building for posterity. They merely wanted to solve technical problems in the neatest and quickest way, but these requirements brought out their mastery. Both the Eiffel Tower (*32*) and Paxton's Crystal Palace (*33*) were demonstrations against the solid, massive concept of building. They are "skeletons without flesh," reduced as far as possible to the bare structural components and avoiding all superfluous mass. Both postulate transparency as a logical consequence of skeletal construction. To preserve this transparency Paxton used a glass casing for his hall. Contemporary reaction was divided between the skeptical or derogatory and the emphatically positive. Paxton's glass hall, clearly betraying its derivation from the hothouse for tropical flora (which Paxton specialized in building), was favored with the name of "Crystal Palace."

The name expresses the enthusiasm of the 1850 generation and the direction of its taste. Enthusiasm greeted the taut, spare skeletal structure, whose tensile strength was openly displayed. There was a movement away from concealment, unclear outlines, and disguise. Such a tendency implied an overt or covert rejection of Classicism, which, however, was still viable through the 1820s and 1830s (in Schinkel's Berlin, for instance).

The situation of European architecture in mid-century can be illustrated by contrasting Paxton's Crystal Palace (*33*) with Gottfried Semper's Federal Polytechnic in Zurich (34). Semper spent the exhibition year of 1851 in London as a political refugee; he therefore knew the Crystal Palace, and even made a design for a theater to be built within it. Later he was appointed to the Federal University of Technology in Zurich.

Semper may have conceived his Polytechnic in terms similar to Paxton's, but his epoch demanded a show of prestige and academicism, and he responded by dressing this important and very permanent edifice in columns and facings, meant to impress upon the beholder not the structural principles but the status and role of the building. An architect like Semper

was no longer merely "Classically" educated: his approach was panhistorical, in a new, inclusive sense. He was preoccupied with the "progress of mankind," from the primitive craft techniques of weaving and carving, to the mastery of tougher materials such as metal, and finally, to modern technology. (His concept of progress was described in his two-volume work *Der Stil*.) It is no mere coincidence that Semper (1803–79) and Darwin (1809–82) were of the same generation: Semper's "style" is nothing less than Darwin's theory of evolution expressed in architectural terms. So it is not surprising that the façade of the Zurich Polytechnic (*34*) should reflect something like an evolution—ascending from the rough lower part of the building to the smooth, ordered upper section.

Paxton and Semper epitomize the contrast between the engineer-gardener and the architect-historian. Semper derived his theoretical insights from an extraordinarily wide study of man's manual skill through the ages; Paxton gained his from an accurate study of botany. For it is not too farfetched to say that Paxton applied the "structural principles" of stem, leaf, and bloom to the building of the glass house. This, incidentally, was quite apt, since the Great Exhibition of 1851—unlike the later Paris "expos"—was not primarily a display of machinery, but in fact a horticultural exhibition. An interior view of the Crystal Palace (*37*) shows the importance given to plants. The growth phenomenon peculiar to the 19th century (population increase, colonialism) was accompanied by a lively import and export of plants, which, thanks to the new hothouses, were able to survive even in unsuitable climates. Plant exchange greatly increased food production on all continents, and Britain recognized its usefulness and value earlier than other nations. Her colonial experience was highly beneficial in this field. It was fitting, then, that the Exhibition of 1851 should be first and foremost a display of plants and a demonstration of growth, housed in a monumental hothouse whose architect was a gardener-engineer. To what extent the concepts of growth—plant-exchange–hothouse–glasshouse—corresponded to the hopes and enthusiasms of the time is attested by structures shown at the Paris fairs of 1855, 1867, 1878, 1889, and 1900 (*39–45*). All are variations on the Crystal Palace (and in the transition from hothouse to exhibition hall the engineer first began to evolve into what he is today). It fell to Eiffel to erect the first transparent tower as a counterpoint to the numerous glass halls. He gave precise shape to the 19th-century vision of a tower: a delicate, transparent, airy web of tensile strength.

37 Sir Joseph Paxton, Crystal Palace. Great Exhibition, London. 1851. Photographic view of the interior. Paxton's structure was assembled in record time in Hyde Park; it was also transportable and could thus be re-created in Sydenham in an enlarged version in 1854. Ingenious solutions were brought to the problems of joins, drainage from the great roof area (through the hollow cast-iron pillars), and wind-bracing. The iron parts are painted like filigree work to make them stand out clearly against the background of sky seen through the glass shell. The hothouse atmosphere is emphasized by the lavish planting of the central hall.

38 Victor Baltard (1805–74), Halles Centrales, Paris. Begun 1853. Unlike Paxton in his Crystal Palace, Baltard did not create a single great space; rather, his large roofed area is divided by *rues intérieures* with individual halls leading off from them. The difference is no doubt partly due to the influence of Durand (*14*).

39 Palace of Industry. World's Fair, Paris. 1855. The ornamentation and organization of this hall indicates a larger debt to great historical models (the Halle des Menus Plaisirs in Versailles, for example) than to the emerging economical engineering practice.

40 Frederic Le Play (1806–82), Alexandre-Gustave Eiffel, and others, Hall. World's Fair, Paris. 1867. Photograph. An attempt was made to create an architectural reflection of the world: the outermost of the ring-shaped halls is devoted to industry, then comes agriculture, then textiles, furniture, applied art, and fine art. The innermost ring, surrounding a central garden, is reserved for a "history of labor." Radially, the hall is divided into standard-sized sections for the displays of the various nations. The interior park allowed the exhibitors a free rein for architectural fantasy. (The Moorish pavilion now on the grounds of Linderhof Castle, near Oberammergau in Bavaria, was acquired by Ludwig II of Bavaria at this exhibition.)

41 Entrance Façade. World Fair, Paris. 1878. After the massive unbroken form was adopted in Paris in 1867 (*40*) came the tendency to interrupt the line of the building with projections.

It became fashionable to incorporate a number of separate domes.

42, 43 Ferdinand Dutert (1845–1906), Galerie des Machines. World's Fair, Paris. 1889. Wood engraving from a photograph and cross section in perspective. The structure, of gigantic three-centered arches on the smallest possible roller bearings, outlived the exhibition it was built for, like its contemporary the Eiffel Tower. Such constructions were no longer thought of as temporary. Iron buildings were now accepted as architecture, on a par with edifices made of more traditional materials, whose structural frameworks were often, after all, steel skeletons.

44 Banquet Hall. World's Fair, Paris. 1900. Dutert's glass-covered machine hall of 1889 (*43*) was put to use again, but only the exterior was considered viable; the interior was completely remodeled and redecorated. Pure construction no longer exercised the same fascination it had eleven years before.

45 Water Palace and Palace of Electricity. World's Fair, Paris. 1900. Interest now shifted to the exciting possibilities of early 20th-century technology—flying machines, the telegraph, electric light. Where the structure becomes only a background, it can be treated more freely and carry more ornament. This happens here, for example, in honor of water power and electricity.

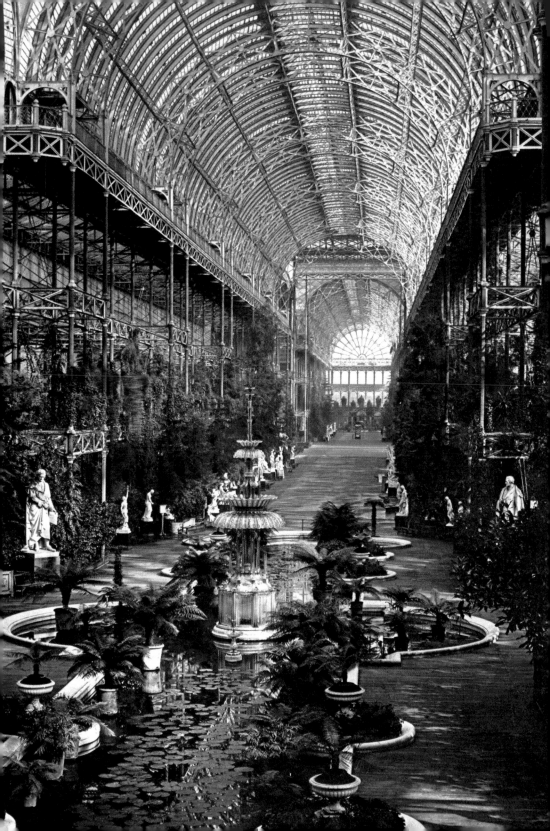

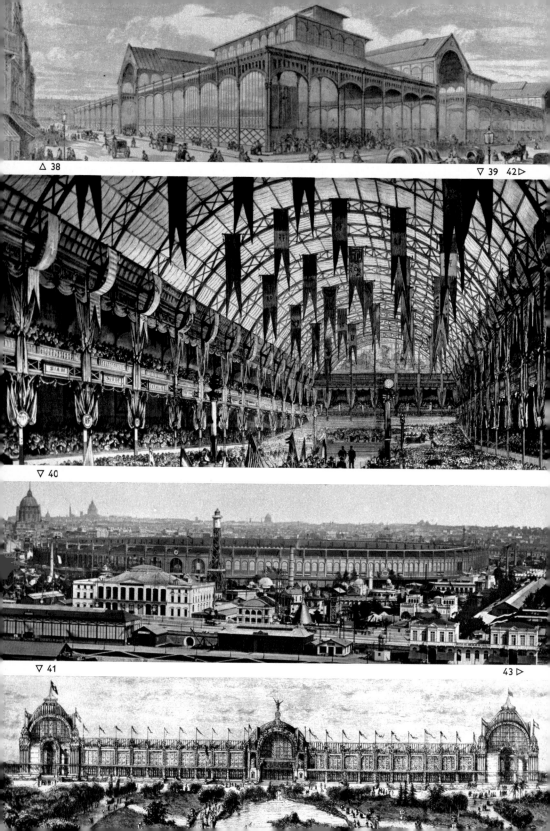

△ 38

▽ 39 42▷

▽ 40

▽ 41 43 ▷

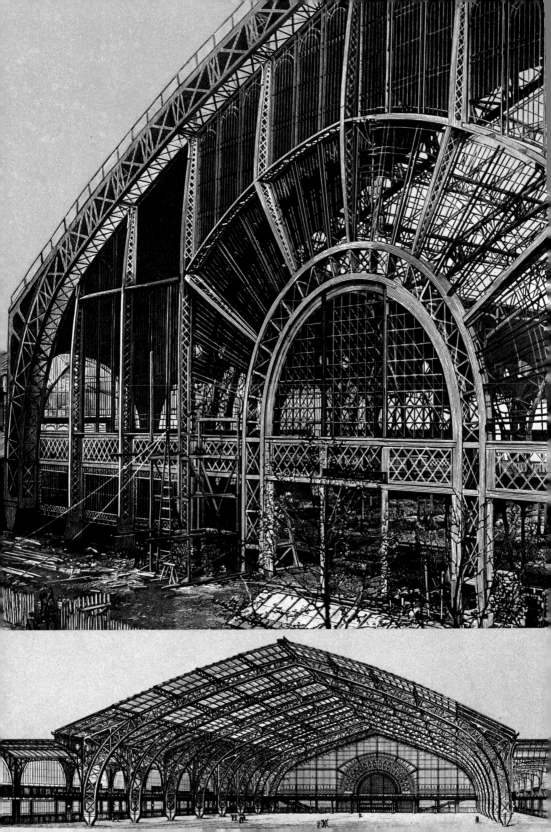

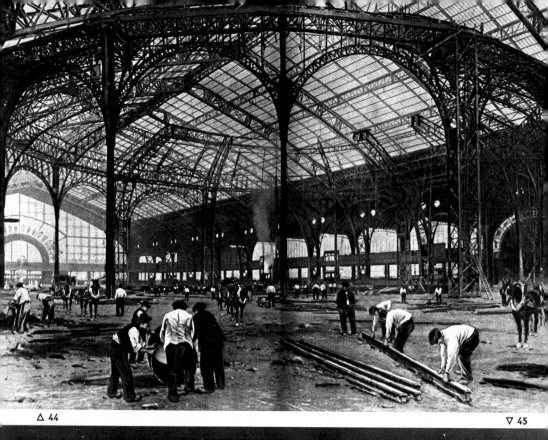

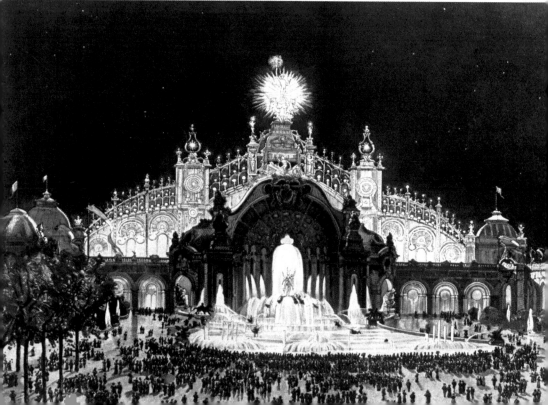

Historicism

In the English garden, the traditional priorities of symmetry and the geometrical relationship of object to surroundings (house, park, lake) were abandoned. The building was no longer the focal point of the entire landscape; it was now isolated in its surroundings. By the same token, buildings were no longer considered as components of an overall grouping, but were designed to be seen individually. This is one tendency that led to what is known as historicism.

The other is the fact that at the beginning of the 19th century not only the English but also the Germans and French systematically set about acquiring a knowledge of the Classical world. Leo von Klenze (1784–1864) and Jacob-Ignaz Hittorff (1792–1867) were among those particularly interested in the architectural past. They made an amazing discovery: that the conventional notion of Classical architecture, pristine in gleaming white marble, needed revision, for research revealed that the ancients *painted* their buildings. When this discovery was published, the architectural brotherhood was plunged into faction and dismay. They could not imagine polychrome Classical architecture, for Goethe's generation had accepted without question Winkelmann's characterization of the Classical spirit as "a noble simplicity and quiet grandeur."

As the research of individual architects brought more and more of the distant past to light, archeological accuracy became a new yardstick for architectural quality. Color was found to have been much used in medieval architecture, as well as in ancient. The architect, forced, for practical reasons, to adopt modern technology, but at the same time, for prestige, pressured to demonstrate his learning, was left with no alternative but to give his building a historical face.

Historical styles were rediscovered in quick succession and later combined more or less at random. Buildings were decorated with stylistic motifs from the past as well as with color, and this led to a superficial revival of Classical art styles, in which some of the formal elements, but rarely, if ever, the complete structures and dimensions of the Classical period, were adopted. Architects soon became aware of this failing, and quite early there was a conscious tendency to reserve certain styles, or even whole genres of architecture, for particular kinds of undertakings, so that the function of the building should be immediately obvious from its stylistic apparel. But these efforts were doomed to failure. Suggestions like those in Heinrich Hübsch's *In What Style Should We Build?* were not carried out, and a fairly arbitrary choice of style remained the order of the day. This was only possible because each building was treated in isolation, uninfluenced by others around it and self-contained in its impact. And because there was no inner, structural justification

for embellishment, decoration ran riot, culminating in the excesses of the 1880s and 1890s, when one may well wonder whether buildings existed primarily for the sake of their stylistic trappings.

Another aspect of historicism is the feeling that what was old should be preserved (up to the time of the French Revolution, old buildings were regularly destroyed to make way for the new). Here an important contribution was made by the new awareness of national identity that was springing up everywhere, seeking to revive past traditions. Medieval quarters of cities were enlarged or restored in what was thought to be the proper historical style. Old buildings were surrounded by new ones in the same style (Houses of Parliament, London, *52*). In new towns, copies of old buildings were erected (University of Virginia, *51*), and there were even reconstructions of ancient buildings (Clermont-Ferrand Cathedral, *46*). Apart from its influence on new architecture, then, historicism inspired the understanding and care of ancient architectural monuments.

New Challenges to the Architect

The 19th century evolved new types of buildings primarily due to three new conditions: "civilization" and technology made great strides; the leading classes and the status needs of young nation-states demanded visible demonstration of this progress; travel and tourism, from small beginnings in the 18th century, increased dramatically.

The predominant civil engineering needs of the 19th century involved water supply and sewerage. Installations to handle this are partly responsible for the geometrical and functional layout of new town building in the period. Favorite assignments at architecture schools were water locks, fountains, fire tanks, fire stations, public baths, and even public lavatories. Expanding industry and trade required such new accommodations as salesrooms, offices, factories, slaughterhouses, and arcades with restaurants and shops. The nation-states that arose after the French Revolution and Napoleonic upheavals had a keen sense of status, which they wished to exhibit in architecture. Older states replaced old forms of cabinet government or absolutism with some kind of parliamentarianism and a civil service administration. These new demands, again, produced new types of buildings. Schools and universities were meant to show that the young states took their responsibility for public welfare and education seriously. During and after the French Revolution, Republican Rome was adopted as the model for the modern state, and therefore the ancient Roman Curia, or senate house, was considered the most prestigious building. Parliament buildings were erected in Paris and London, then later also in Vienna, Bern, Berlin, and elsewhere.

54

Codes of law, similar to the French Napoleonic Code, were established in a number of countries. Jurisprudence, another central concern of the Roman state, received symbolic expression in law courts in both Europe and America, and in new prisons—"houses of correction" that also serve the law—as well. The new civil code permitted secular burial, too, and in consequence great nondenominational cemeteries and crematoriums came into being.

Banks and stock exchanges symbolized universal prosperity; the museum was a 19th-century innovation; and theaters, exhibition halls, club houses, and concert halls catered to the public interest.

Such a list of new building types should not give the impression that there were formerly no banks, law courts, theatrical presentations, or parliaments, but buildings designed expressly for these purposes were not built until after (or shortly before) the French Revolution. Previously, drama was presented in the ballrooms of great estates, the law was located in medieval council chambers, concerts were given in monastery cloisters, and so on. Such buildings have existed for centuries, and were often adapted or modified to suit new requirements, as long as the population and the size of cities did not increase too rapidly.

But after the Revolution and the changes it brought, towns and populations grew extremely fast, so that more comfortable and specialized quarters were needed; the 19th century responded with law courts, parliaments, concert halls, and stock exchanges.

Goethe, in his famous Italian journey, did not invent the Grand Tour. It was considered the duty of every civilized European to travel. In the 19th century, education was oriented toward the amassing of encyclopedic knowledge, and those in search of such knowledge were expected to seek out for themselves famous sites all over the world. Travel, then, became a commodity in great demand, and, particularly with the advent of railways, enterprising people were quick to exploit the demand by setting up travel agencies. It was only natural that storage sheds, hotels, and shops should spring up around the great new railway terminals, all catering primarily to the needs of tourism. Places of scenic beauty also became centers of pilgrimage, suitably enhanced by architectural embellishment. Hotels were constructed in the Alps and arose along the beaches of the Côte d'Azur and the Chalk Cliffs of the English Channel, all with the affluent tourist in mind (63–70).

To protect travelers from the weather, most railroad stations were equipped with galleries modeled after the hall structure invented for the London Great Exhibition in 1851 (55). Frequently there were conflicts between the prestige function of the station as a modern "gateway to the city" and the technical demands of construction, and it depended on the skill of individual architects whether the two opposing demands were successfully

46 EUGÈNE-EMMANUEL VIOLLET-LE-DUC (1814–79), DESIGN OF FAÇADE FOR THE CATHEDRAL OF CLERMONT-FERRAND. 1864. In this project, Viollet-le-Duc shows an astonishingly accurate knowledge of French Gothic; every detail is substantiated by evidence. Viollet was an outstanding restorer of historical monuments; here he tried to combine motifs from the past with the latest advances in engineering. He needed no longer depend on the sheer mass of the stone for supports, like the medieval builders, but could afford to reduce the girth of the pillars and other structural items. This façade is a reminder that a few years later in the U.S.A. the steel-frame building would begin to come into its own.

47 LEO VON KLENZE (1784–1864), VALHALLA, NEAR REGENSBURG. 1830–42. The building was intended as a monument to German unity and a memorial to famous Germans. After a lengthy planning stage, Ludwig I of Bavaria finally laid the foundation stone in 1830, on the anniversary of the battle of Leipzig (1815). Above the huge base of stepped platforms rises a vast temple, whose massive dimensions could only be spanned by an iron framework for the roof. Vaulting the roof—a solution used in the large church of the Madeleine in Paris—was rejected by Klenze as un-Greek.

48 EMILIO DE FABRIS (1808–83), FAÇADE OF FLORENCE CATHEDRAL. 1866–87. The 19th-century imagination was always stirred by ruins and unfinished buildings, and feelings ran particularly high in the competition for designs to complete the façade of the famous cathedral of Florence, S. Maria del Fiore. De Fabris' solution leans heavily on the style of the 14th-century Campanile and represents a compromise between the views of the warring parties.

49 J. F. BENTLEY (1839–1902), WESTMINSTER CATHEDRAL, LONDON. c. 1895. The Archbishop's seat in London is decorated with the forms of the Italian Middle Ages. The cathedrals of Siena and Lucca served as models, as a conscious attempt was made to refer to the traditions of church-building towns and communities.

50 THOMAS HAMILTON (1784–1858), HIGH SCHOOL, EDINBURGH. Begun 1825. Edinburgh earned the name "Athens of the North" with a series of gleaming new buildings in the Greek style, which included this high school. The temple-style central building is given side wings and combined with quasi-Egyptian details. Although individual forms are based on Classical models, the coherence of Greek architecture is lacking here.

51 THOMAS JEFFERSON (1743–1826), LIBRARY, UNIVERSITY OF VIRGINIA, CHARLOTTESVILLE, VA. 1817–26. Jefferson was an admirer of European architecture. He made the Grand Tour; he saw Rome. Although here he strongly alludes to the Roman Pantheon, he also departs considerably from his model. How unthinkable, from a Classical point of view, that it should be executed in brick and decorated with a white portico and white window frames!

52 SIR CHARLES BARRY (1795–1860), HOUSES OF PARLIAMENT, LONDON. 1840–65. In England the Gothic tradition never completely died out; the maintenance of the great cathedrals guaranteed continuity of the skills and the ways of the old masons. When Sir John Soane's extension of Westminster Palace burned down in 1834, a Gothic Parliament building was bestowed upon the nation. Its organization and ground plan are totally un-Gothic; they were adapted to the complicated needs of English parliamentary procedure and ceremony.

53 GOTTFRIED SEMPER, OLD COURT THEATER, DRESDEN. 1832–42. Burned 1860. Contemporary photograph. This building made the young Semper famous. It is basically a cube, a combination of stage area, to which staircases are joined on the left and the right, and an auditorium flanked by lobbies. The approach is reminiscent of Gilly's Berlin Theater project (24). Obvious at first sight is the way the building remains unrelated to its surroundings; it appears tightly contained, almost alien. Surface features, while clearly articulated, are done in very low relief, as seen in the sgraffito ("scratched") decoration of the upper part of the auditorium.

54 GOTTFRIED SEMPER, NEW COURT THEATER, DRESDEN. 1871–78. Semper had the opportunity to formulate the same structure as a mature work. Because of the axial pull of its lofty porticoes, the building now clearly strives to relate to its surroundings. This change in

46

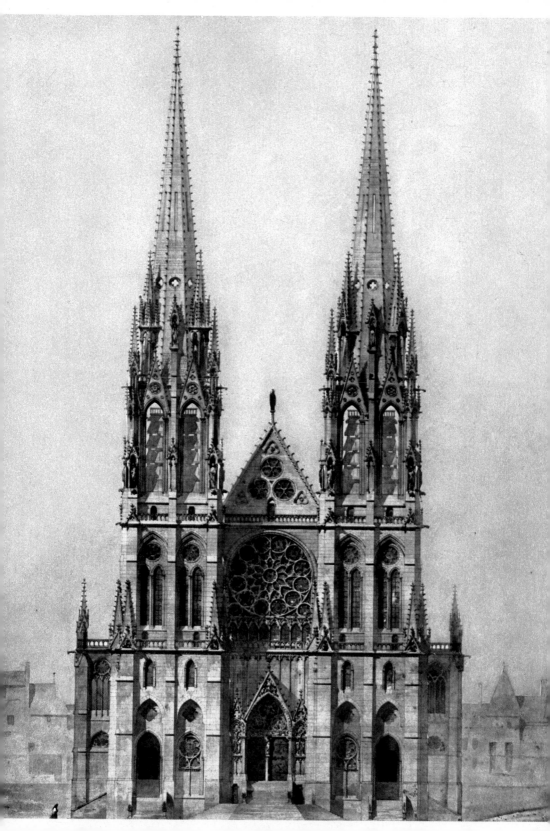

△ 47 ▽ 48 ▽ 49

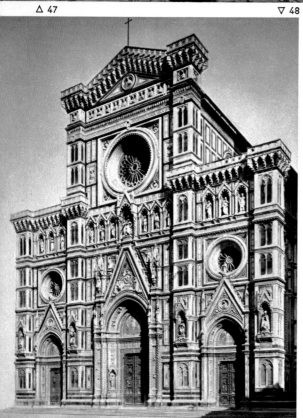

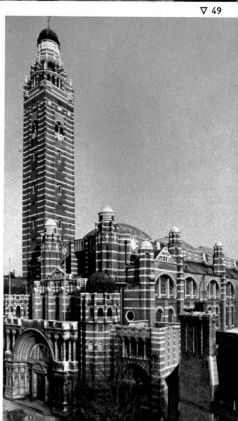

△ 50

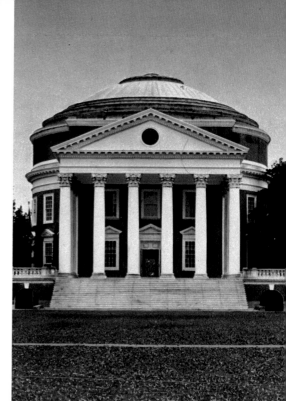

▽ 52 △ 51

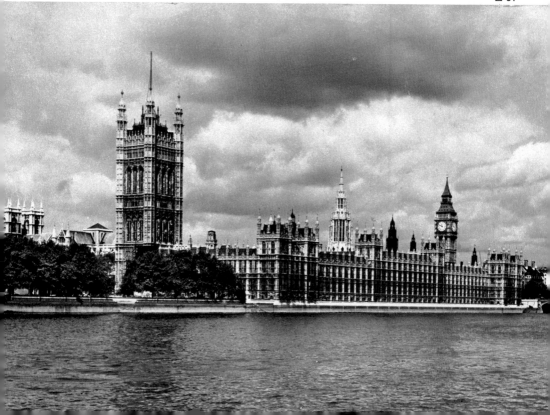

△ 53

▽ 54

reconciled. It is characteristic of these buildings, in fact, that they required the most advanced engineering, since they were much bigger, more complex, and used by greater numbers of people than anything that preceded them. Engineering knowledge was applied not only in the railway station concourse, but also, less visibly, in theaters, law courts, museums, and galleries. The dimensions of pre-Revolutionary buildings no longer sufficed; what remained was merely the historicizing decoration. Garnier's Paris Opera (57) and Semper's Federal Polytechnic, Zurich (34), would not have been feasible without iron girders to support ceilings. And so, in yet another sense, historical tradition was abandoned: function became more important than style.

Semper's approach was no doubt partly conditioned by the fact that he had built an art gallery in the 1850s very close to the site; features of the new theater distinctly echo elements of it. The façade is the focal point of the new design. Every part of the building is visible from the royal palace, in the heart of the old city, to the detriment of the clear cubic relationships. The two Dresden theaters amply demonstrate how Semper's intentions changed markedly between the completion of his early project and the beginning of his late one.

55 ISAMBARD KINGDOM BRUNEL (1806–59) AND SIR MATTHEW DIGBY WYATT (1820–77), PADDINGTON STATION, LONDON. 1852–54. This is an example of pure engineering. There are scarcely any references to historical styles. The station is an entirely functional structure, not burdened with the need to represent a "city gate," and therefore able to dispense with historical masking.

56 GIUSEPPE MENGONI (1829–77), GALLERIA VITTORIO EMANUELE, MILAN. 1865–77. This arcade is the meeting place of the elegant world. Its dimensions and the need for maximum light called for an iron and glass roof; however, the walls of this covered street are decked out in suitably impressive stylistic costume, and in fact every possible area of the roof-skeleton itself is decorated. The pendentives of the dome, very important zones from an engineering point

of view, are separated from the architectural façade by "neutral" semi-circular painted areas.

57 CHARLES GARNIER (1825–98), OPERA HOUSE, PARIS. 1861–74. As the center of Napoleon III's empire, Paris was graced not only with new street plans and extensions of the Louvre, but also with an opera house, whose size, expensiveness, and rich finish were a lavish demonstration of confidence in France as the cultural center of the world. However, although built by command of the emperor for the rarified atmosphere of the opera, the building became the showplace of the upper middle class and its cultural and social pretensions. This confident structure, with its pronounced formal features, is a masterly combination of architectural and engineering conceptions. Individual forms everywhere proclaim their dependence on a strengthening iron framework specified by the engineer. Technology carries an elegant, historicizing fabric.

58 EDUARD VAN DER NÜLL (1812–65) AND AUGUST SICCARD VON SICCARDSBURG (1813–68), STATE OPERA, VIENNA. 1861–69. This foyer forms a contrast with the exuberant one in Paris (57). Although the Emperor Franz Joseph I built his opera house on the new Ringstrasse, it is not a young power that is showing its cultural standing here. The formal features are therefore correspondingly more reserved. While in Paris the structural engineering lies directly

beneath the formal fabric, the Vienna Opera is for the most part built exactly as its formal exterior would suggest: modern in its adoption of modern techniques and current styles, but thoroughly traditional in construction.

59 JOSEPH POELAERT (1817–79), PALACE OF JUSTICE, BRUSSELS. 1866–83. From a contemporary drawing. The palace is a cross between functional building for the state judiciary offices, an evocation of the power of justice, and a national monument to the Belgian state, which had been independent since 1830. Although the Belgian High Court is housed in this building, to our modern way of thinking the proportion of used space to total space is extremely small. The generous scale of halls, corridors, and staircases shows the importance accorded to demonstrating the dignity of the state and of justice. The crown surmounting the central structure plainly indicates that the king is the supreme overlord of the judiciary. The vast building thereby becomes a national monument.

60 HANS WILHELM AUER (1847–1906), PARLIAMENT BUILDING, BERN. 1894–1902. It is clear that the republican traditions of ancient Rome are to be continued in late 19th-century Bern. The Latin inscription indicates as much. But formal elements individually allude to all the republican periods of the past—the Florentine Renaissance and the French Revolution, for example. The Swiss obviously wished their state building to have a monumental function.

61 HERMAN AUGUST STADLER (1861–1918) AND EMIL USTERI (1858–1934), JELMOLI DEPARTMENT STORE, ZURICH. 1899–1901. A steel skeleton filled in with glass was now felt to provide a façade reflecting the status of a quality department store. This type of architecture, once appropriate only for temporary exhibition halls, has become acceptable for the most important street of an up-and-coming city.

62 ROBERT MOSER (1833–1905), LENZBURG PRISON, SWITZERLAND. Completed 1864. For the new Swiss Canton, even a prison was a prestige building representing the state. The five-armed layout is crowned by an eight-sided chapel. A project that was not bound by tradition and yet served a clear function allowed this experiment with a polygonal system.

63–70 HOTELS FOR TOURISM. Apart from a few rather free patterns, buildings in this group fall into three main design categories: the palace type, frequently based on the Tuileries Palace, Paris (69, 70); the castle type, in which the guests are meant to see themselves as "lords and ladies" (63, 66, 68); the picturesque local type—in the Alps, oversized chalets (65, 67); in the Orient, princely residences (64)—in which the guest becomes an Alpine herdsman or a maharajah.

71 GIUSEPPE SACCONI (1854–1905), MONUMENT TO VITTORIO EMANUELE II, ROME. 1885–1911. The dimensions of the monument are so massive that they completely dwarf the equestrian statue in the center. The base here functions as a kind of stage with the colonnade as a backdrop, "supported" by the giant pylons, or gateways, on either side. This national monument is an exercise both in a new type of cubical formation and in composition on a grand scale; as in the earlier exhibition-hall projects, the site provided the freedom and the space in which to experiment.

72 BRUNO SCHMITZ (1858–1916), KYFFHÄUSER MONUMENT, THURINGIA. 1895–97. The unifier of the German Reich, Kaiser Wilhelm I, received his share of monuments. Here the monument consists of a podium and nothing more, rather like the Palace of Justice in Brussels (59). This memorial is not a complicated three-dimensional stage set, but it may be seen as an accessible stage-like structure; by way of steps, gate, tunnel, and courtyard, the visitor approaches the tower surmounted by the imperial crown.

73 JEAN-FRANÇOIS CHALGRIN (1739–1811), ARC DE TRIOMPHE, PARIS. 1806–35. Suitably enough, this monument to the soldier-emperor, this Tomb of the Unknown Soldier, this triumphal arch of the victorious army, this Gate of Honor has, like all Napoleon's edifices, a Roman look. (A plan for a crowning quadriga was never carried out.)

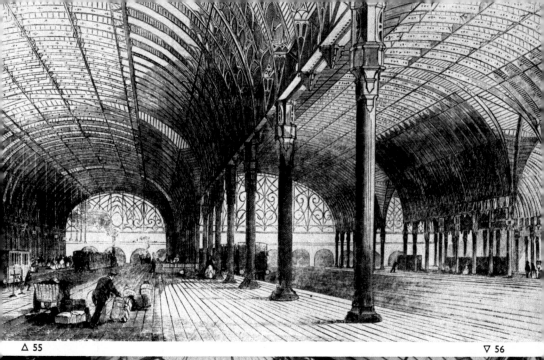

△ 55

▽ 56

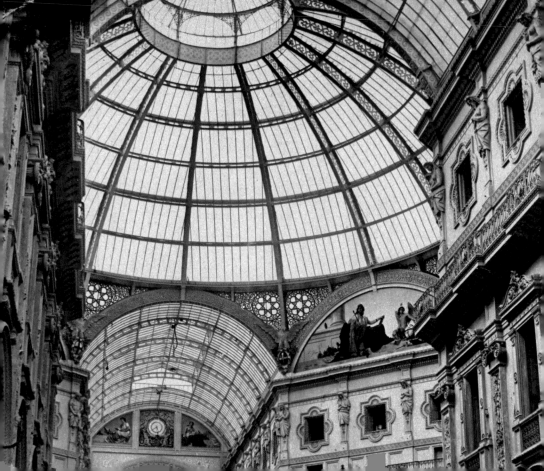

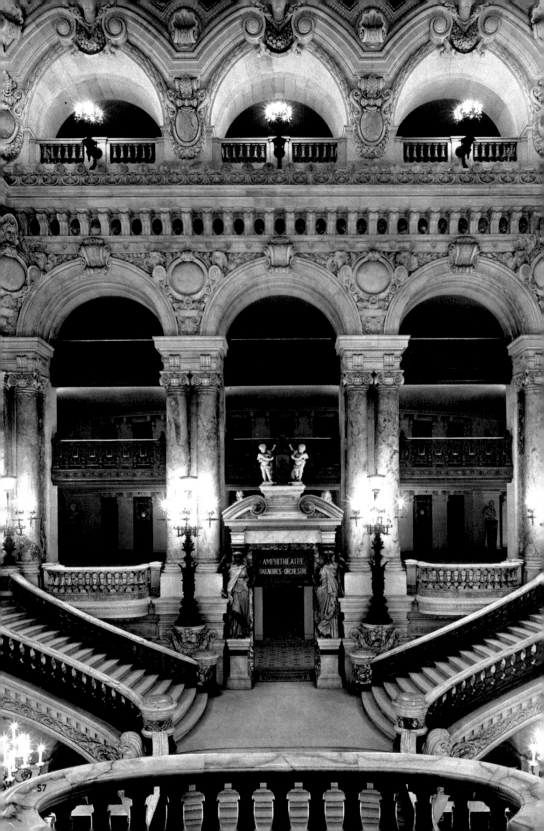

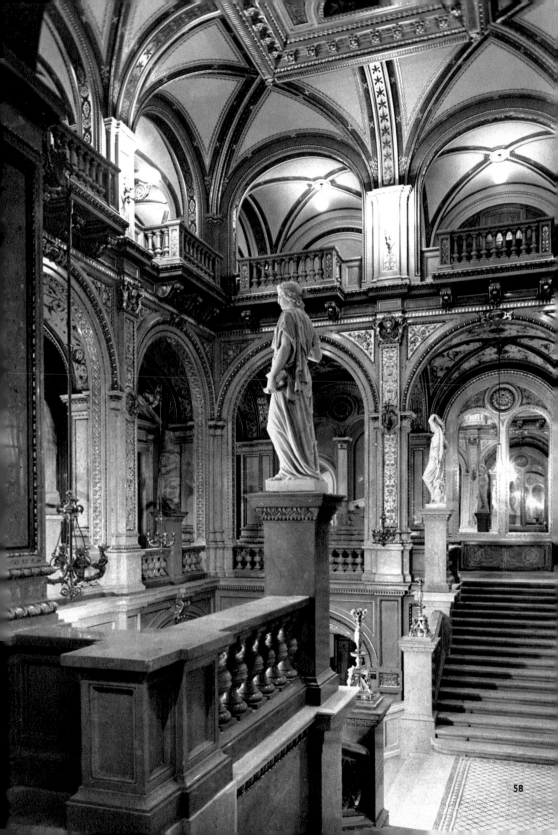

58

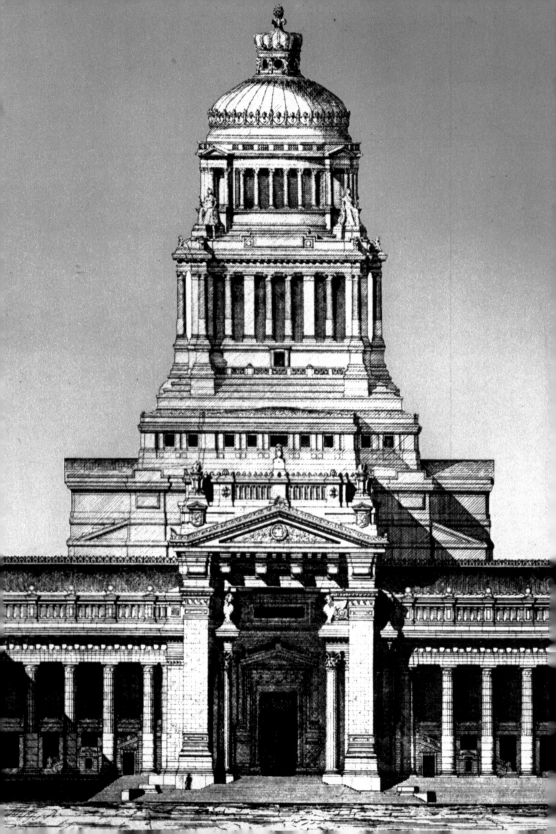

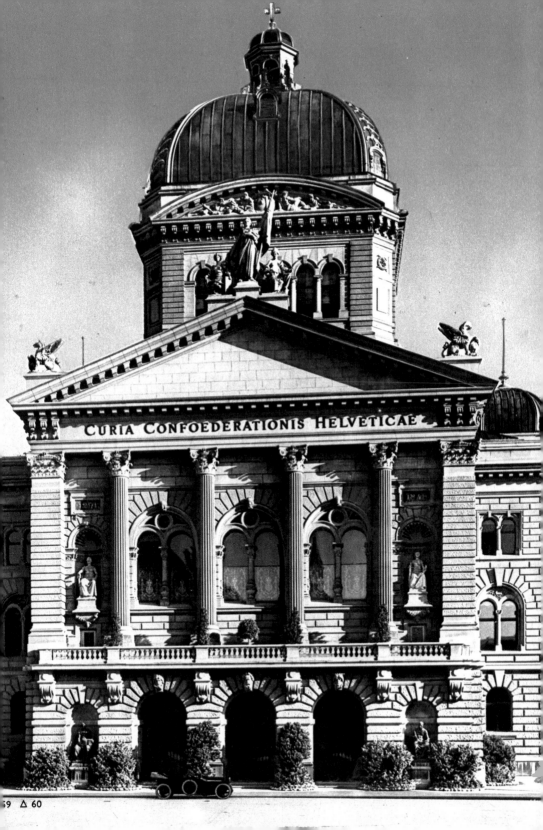

CURIA CONFOEDERATIONIS HELVETICAE

△ 61

▽ 62

△ 63

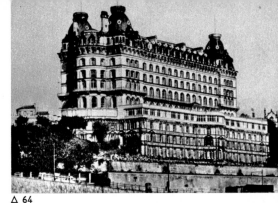

△ 64

△ 65

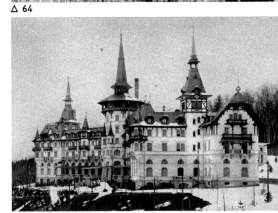

△ 66

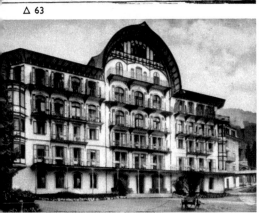

△ 67 ▽ 69

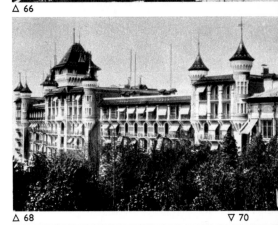

△ 68 ▽ 70

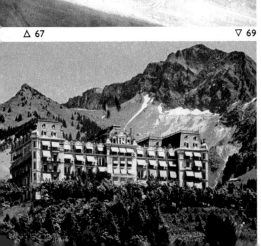

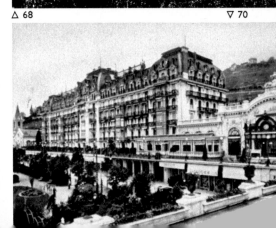

△ 71

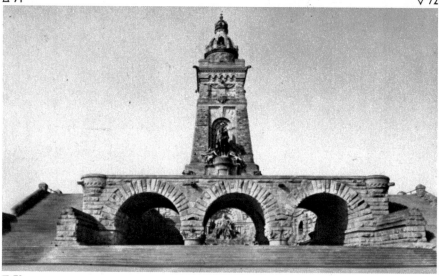

▽ 72

▽ 73

Chicago School

American architecture had a much earlier international influence than American sculpture or painting (which did not achieve independence until the 20th century). At first, the American contribution was entirely pragmatic; it was unconcerned with debates about theory or esthetics, but for that reason very much connected with the rational use of space (surface area), time (duration of construction), and money. It quickly became apparent how much genuine artistic potential existed within this concept of utility and efficiency.

The Chicago School began to show its paces when a third factor, the more economical use of ground space made possible by the skyscraper, was added to the other circumstances that conditioned American concepts of architecture: the flexibility of the ground plan and reduction of construction time. The two latter requirements have a typically American explanation. As far as flexibility of the ground plan is concerned, very often the American home was built with the idea of extension at a later date in mind; this led to a widespread use of the cruciform ground plan (74). The cross, with vertical and horizontal axes that intersect at the fireplace, allows for a natural extension on all four sides. As for reduction of building time, the high mobility of the population and rapid construction of settlements made prefabrication of whole sections of buildings—such as complete walls in wooden structures—an urgent requirement. It is probable that the "balloon-frame" system, whereby a wooden house could be quickly put together like a box, with the walls attached to a ready-made frame of the lighest construction, developed in Chicago itself. Similar principles were put to use in what is known as "Chicago construction," but instead of a wooden frame and shingled wooden planks as cladding, we find an iron skeleton and thin, smooth walls (76). Building sections, then, became identified by their supporting or their separating roles. Basically, the Chicago School first of all conceived the high structure as a skeleton, exactly like an exhibition hall, clothed or screened by a thin skin of wall with as much window surface as possible. This engineering conception, which was combined with traditional form in the detail work, characterizes the skyscrapers of American cities; with modifications, it was adopted around the world in the 20th century. It is interesting to note that one of the originators of "Chicago construction," William Le Baron Jenney (1832–1907), was born in the same year as Alexandre-Gustave Eiffel. The methods of Chicago building possessed no particular artistic merit in themselves, but they created new possibilities for the artist, and to some extent they also excluded some traditional solutions. The good fortune of Chicago in the 1880s and 1890s was that there were artistic talents on the spot who could make of the high-rise concept something more than a practical engineering formula. The beginnings, admittedly, were fundamentally European;

74 G. E. WOODWARD, AMERICAN COUNTRY HOUSE WITH CRUCIFORM PLAN. 1873. The constructional skeleton of the house is a thick plank frame. This is covered by horizontal wooden boarding sealed with vertical laths at the corners. The skeleton of the building shows through in verandas and bay windows.

75 CHARLES F. ANNESLEY VOYSEY (1857–1941), BROADLEYS, LAKE WINDERMERE, ENGLAND. 1898–99. Voysey consciously adopted older stylistic features for his country house, including bay windows and a traditional overhanging roof, which, however, he constructed with slate instead of thatch. In the organization of the ground plan and in fine craftwork, too, old traditions are revived. The architect has obviously taken note of the reform movement inspired by John Ruskin (1819–1900) and William Morris (1834–96) during the second half of the century in England.

76 WILLIAM LE BARON JENNEY (1832–1907), STEEL SKELETON OF THE FAIR BUILDING, CHICAGO. 1891. The steel frame with suspended floors offers the maximum internal flexibility. But even at this date a building was not acceptable without a stone facing; the impression of "being properly built" could still be created only by masonry. Stylistic or decorative ornamentation, however, was confined to the entrance and roof areas.

77, 80 LOUIS HENRI SULLIVAN (1856–1924) AND DANKMAR ADLER (1844–1900), AUDITORIUM BUILDING, CHICAGO. 1887–89. The gigantic building-block is manipulated, with obvious effort, into a "stylistic" arrangement of stories. The lower area is three stories high; the central area consists of four stories. Beneath this costume, however, the steel skeleton is discernible. There is no longer any real attempt to hide it, despite the stone façade. In keeping with the massive size of the building, the details (80) run to giant proportions.

78 LOUIS HENRI SULLIVAN AND DANKMAR ADLER, GUARANTY BUILDING, BUFFALO, N. Y. 1894–95. In contrast to the Auditorium Building, this structure has been organized vertically, which gives it a far more coherent appearance, as well as the effect of an unlimited number of stories. The cornice molding, as the crowning touch, is accentuated by ornamentation—a feature left over from horizontal thinking.

79, 81 LOUIS HENRI SULLIVAN, CARSON, PIRIE & SCOTT DEPARTMENT STORE, CHICAGO. 1899–1904. With their increased surface area, buildings began to be designed with a single corner as focal point; as seen here, Sullivan also adopted this widespread 19th-century pattern. He concentrated his ornamentation on this point, and the horizontal bands formed by the two façades converge here, culminating, as it were, in the vertically oriented round tower that soars above the ornate entrance.

82 BRUCE PRICE (1845–1903), PIERRE LORILLARD HOUSE, TUXEDO PARK, N.Y. 1885–86. The horizontal accents created by the verandas pushing out to right and left are checked by the strong verticals of the chimneys next to the entrance. The windows are not apertures in the wall; they are formed by open spaces left between closed layers. Although unarticulated by special ornamentation, the component parts of the building have begun to acquire individual voices.

83 FRANK LLOYD WRIGHT (1869–1959), MARTIN HOUSE, BUFFALO, N.Y. 1904. Wright uses three basic compositional elements: projecting eaves, masonry supports with the function of walls, and open spaces that form window areas. (The walls sometimes have apertures, but these windows have a different character.) The easy legibility of the small, low-elevation features against the larger elements gives the impression of transparency and of horizontal stratification.

SPIEGLE. Sc.

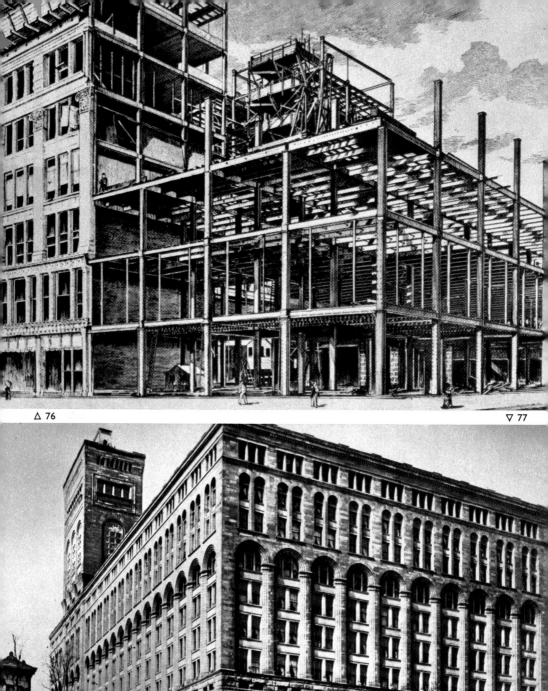

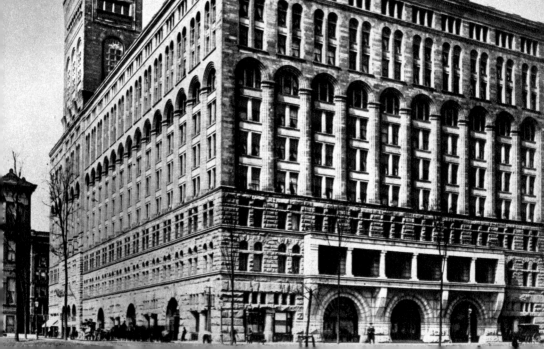

△ 78 ▽ 80 △ 79 ▽ 81

△ 82

▽ 83

this is reflected especially in the work of Henry Hobson Richardson (1838–86) and Louis Henri Sullivan (1856–1924). Sullivan's Auditorium Building, Chicago (*77, 80*), has a familiar effect of accentuated heaviness, with its rustic stonework on the lower stories; the coat of stone clearly derives from a continuing fascination with medieval buildings in Europe, especially Romanesque churches. But in Sullivan's work the Romanesque element rapidly gave way to an ever-increasing frankness about the basic iron framework, to which he gave prominence even in the external appearance of the structure.

The wide "Chicago window" came to the fore (*79*), perhaps because the narrow, canyon-like city streets needed as much light as possible. But Sullivan's temperament did not confine itself to functionalism—that is, to dealing with the requirements of economy, safety, flexibility (of office ground plans), and light supply; in the visually accessible area of the lower stories he insisted on a sculptural treatment of the walls (*80*). Initially he made a great effort to encase his massive structures in Romanesque and Gothic forms; later, in written pieces as well as in his architecture, he fought for the retention of ornament (*81*), and in so doing he produced a singular canon of ornamental motifs (including thistles and thorns, sometimes with the appearance of skin stretched taut to the point of tearing). This first American achievement in decorative art is easily worthy of comparison with the best produced by European Art Nouveau in this line.

Apart from the city skyscraper, America created a very distinctive version of the affluent private house. It was quite natural that, at first, successful Americans should attempt to model their country houses on the English style, for since the 18th century England had produced the most felicitous pattern for an effortless, asymmetrical blending of house and garden—and what all of Europe borrowed from England was at first borrowed by America too. But already in the indigenous American "shingle style," as used for example in the large-scale country houses by H. H. Richardson, there are features that clearly depart from the English tradition—for instance, the bold yet tranquil projection of horizontal lines (particularly in the eaves), which is unique.

Art Nouveau

In the last years of the 19th century, something almost unimaginable was achieved: the control of historical concepts of form, of so-called styles. This consummation, so devoutly wished and so long attempted, occurred in a whole series of European cities.

The preoccupation with tradition and culture had brought about stylistic revivals, but these "styles" were nothing more than forms borrowed for important buildings. The borrowing took place, however, at a time when all concerned were also preoccupied with the

structure of the building: Durand developed his own system, Schinkel wrote home from England about the building of silos, Semper experimented with the most appropriate and sympathetic treatment of materials as the basis for style. In inconspicuous spots these new building structures were tried out. Reference to "styles" was thus becoming more and more just payment of lip service.

But where was the fascination of the new, the attraction of what indisputably bears a personal stamp? Without doubt, it was largely the engineer who had the greatest satisfaction at the time, for by means of pure calculation he was able to arrive at a new format —as the various international fairs amply demonstrated. The development of Art Nouveau at the turn of the century, or Jugendstil as it was known in German-speaking countries, opposed with something radically different this calculated, rationalized creativity.

As the staircase by Victor Horta in the Tassel house, Brussels (*84*), shows, Art Nouveau elongated nearly every form: in place of the circle, square, or right angle, we find the oval, the hyperbola, the endlessly flowing line. Instead of symmetry, there is a rejection of balanced forms; instead of harmony, mystery. Only at its two extremities, top and bottom, does this staircase make any concessions to the traditional decorative order. The rest is elongated, attenuated, sinuous. Even the iron supports turn into reeds or stalks, throwing out narrow spear-shaped shoots that unfold luxuriantly and asymmetrically.

Certain animals and plants suited the Art Nouveau mood and are therefore especially common as motifs—for instance, the lily and the swan. Both are volumetric, while at the same time airy and ethereal. Water can effortlessly bear the white feather ball of the swan, air can fill the rich curves of the iris-like sails, for both command ample space but are without corresponding weight. This contrast of space and weight seems to bring us close to the theoretical essence of Art Nouveau. The idea that such "weak" elements as water and air are in reality strong, or can be strong, fascinated a generation that saw in nature something more than the mere challenge to rational, calculating mastery.

About 1900, the American dancer Loïe Fuller made a triumphal tour, enjoying ovations, through the capitals of Europe with her "skirt dance," which tells us more about the secret yearnings of her generation than about the dancer herself. In her dance she trailed through the air billowing streamers of filmy material—as light as swansdown, as lavishly curved as lilies. She charmed not so much by graceful movements of her body as by the movements of the floating veil. Thus she appeared borne up by a seemingly yielding element. Being suspended in air, floating lightly on water—these were the desired sensations, and they were best embodied in the arts of dance, glass-making, ceramics, and book illustration.

It could be argued with justification that Art Nouveau was essentially anti-architectonic,

and yet the effect of the movement on architects was powerful, even if limited geographically to certain cities. Apart from Brussels (Horta), we could mention Barcelona (Antoni Gaudí), Glasgow (Charles Rennie Mackintosh), Paris (Hector Guimard), and Darmstadt (Josef Maria Olbrich); for good measure, we might add Turin (Raimondo D'Aronco), Munich (Richard Riemerschmid), and Vienna (Otto Wagner, Josef Hoffmann).

Hector Guimard (1867–1942) is a good middle-of-the-road representative of Art Nouveau. In his Paris Métro entrances (*87*), glass is related to sheet iron as the flower relates to the leaf, and the labyrinthine Métro tunnel system finds suitable expression in the "mystery" of Art Nouveau forms.

For the extremes in the Art Nouveau spectrum we have to look (whether by coincidence or not) at the northern and southern perimeters of the movement: Glasgow and Barcelona. In both cities an individual architect created his own version of the style. Antoni Gaudí (1852–1926; *85*) had the richest vocabulary and the greatest creative vigor of all Art Nouveau architects. He built a compendium of architectural idiosyncracies without compare, with the possible exception of certain Baroque rivals. The Scot Charles Rennie Mackintosh (1868–1928; *86*) represents the opposite pole: he strictly preserved rectangular forms. But his right angles do not lead to apertures, as one might expect; his buildings are shut off and shielded in the extreme. A school becomes a fortress, a fortress becomes a dungeon. There is "mystery" here, too, but with Mackintosh it lies not in the curve of a line but in the forbidding impenetrability of his architectural mass.

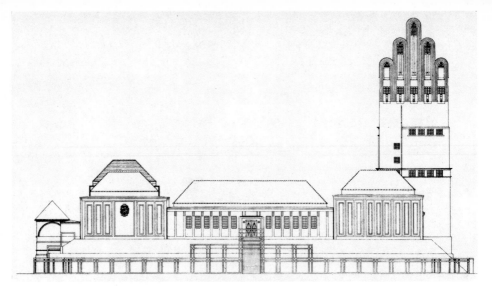

JOSEF MARIA OLBRICH, EXHIBITION GALLERY AND "WEDDING TOWER," MATILDENHÖHE, DARM-
STADT. 1907–8. Elevation of the east front. See *88*.

84 VICTOR HORTA (1861–1947), TASSEL HOUSE, BRUSSELS. 1892–93. Spatial relations are no longer governed by axial principles. Component parts no longer rest statically upon one another; they flow into and evolve out of each other. Between the capital of the pillar and the joint above there is area where lines of force converge, pressing down and pressing up. These lines are accentuated by wrought iron-work and painting. The whole generates the impression of a swelling, wave-like movement.

85 ANTONI GAUDÍ (1852–1926), CASA BATLLÓ, BARCELONA. 1905–7. Gaudí deliberately flouts the laws of stasis, denying the fact that weight is a force. This façade is not, therefore, a reflection of the true play of force in the structure, but a superimposed organic growth. The "roots" form the lower section, the "blossoms" the upper.

86 CHARLES RENNIE MACKINTOSH (1868–1928), SCHOOL OF ARTS, GLASGOW. 1897–1908. This wing was constructed 1907–8. The masonry sections become narrower toward the top, enabling the window-supports to be super-imposed one upon another, while resting on solid, secure structural elements. The attraction of the composition lies, therefore, in the precise presentation of the structural facts and in the natural treatment of the components.

87 HECTOR GUIMARD (1867–1942), PLACE DE L'ÉTOILE MÉTRO STATION, PARIS. 1900. Hector Guimard built a series of stations in Paris (as Otto Wagner had earlier designed trolley stations in Vienna). Guimard derives lines of force from organic forms; at the same time, the true rectangular structural framework powerfully asserts its underlying presence. The tendril motif beloved of the Art Nouveau movement is used here as decoration.

88 JOSEF MARIA OLBRICH (1867–1908), EXHIBITION GALLERY AND "WEDDING TOWER," MATILDEN-HÖHE, DARMSTADT. 1907–8. Around 1900, the grand duke of Hessen and Josef Olbrich, with a group of leading young artists, set up the artists' colony of Mathildenhöhe. In this complex of buildings, Olbrich's purpose is not organic decoration but organic composition. The ornamentation is relatively restrained, the proportions are well balanced, the curvatures lightly handled; such qualities contributed to the world-wide interest aroused by German works of the period. Among other artists, Frank Lloyd Wright traveled from America to Germany to study them.

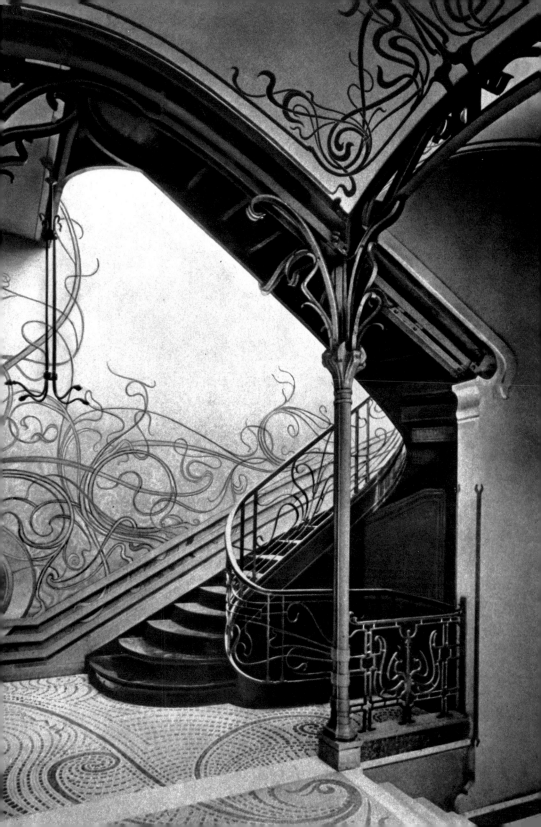

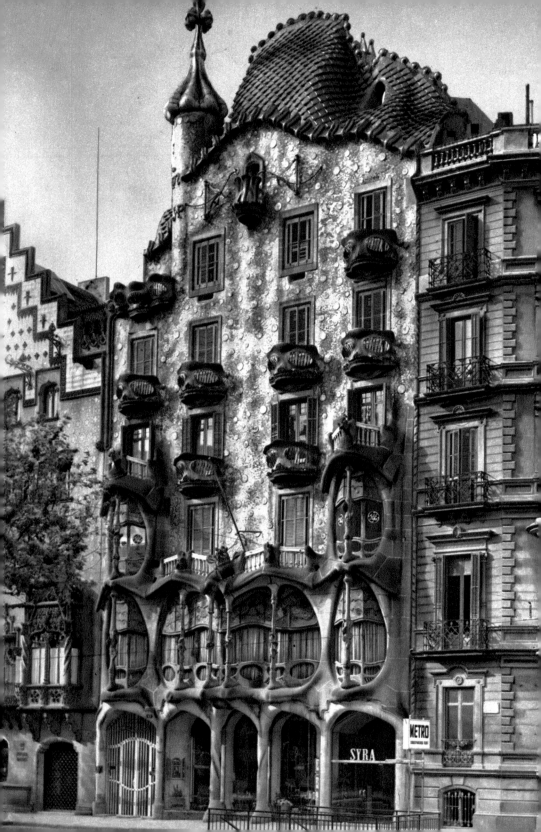

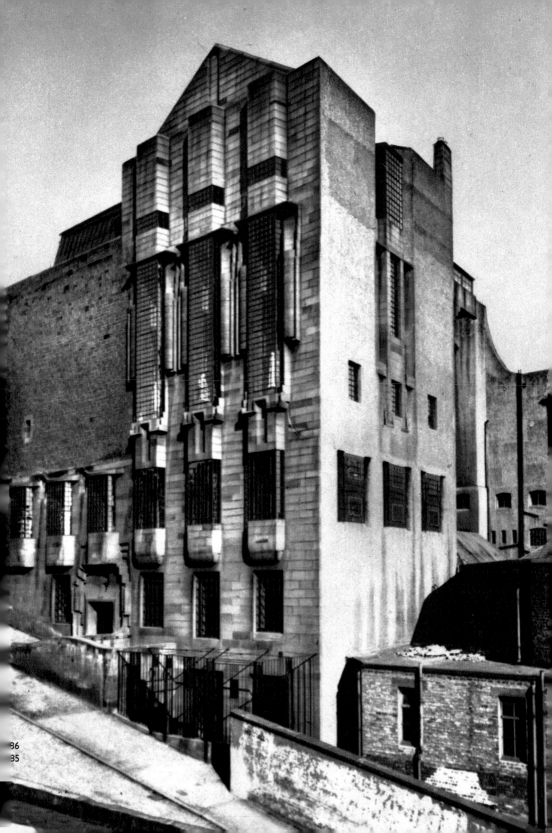

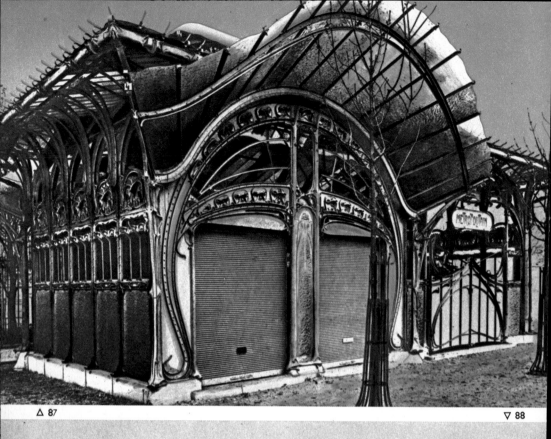

87

88

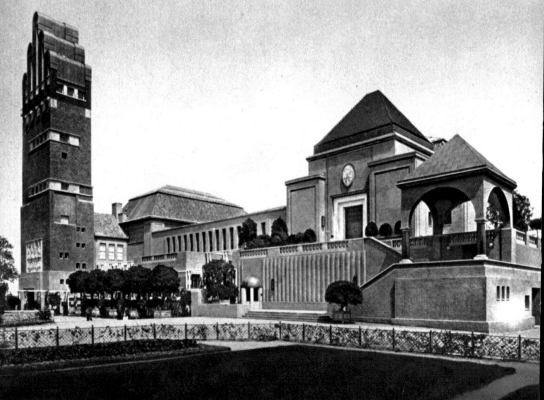

SCULPTURE

Sculpture is not one of the leading areas of endeavor in 19th-century art. The average man would probably think first of painters, then of architects and engineers among 19th-century artists; sculptors would take a poor third place. In fact there is only one sculptor of the period—Rodin—who enjoys the same reputation as the painters.

There is no doubt that this is a short-sighted judgment that will eventually be corrected, but there are reasons for it. We shall touch here only on those generated by the conflict between commission and free creation. In the European tradition, the sculptor is hired by the architect, and no matter what the architect's bent—toward "style" (as defined in the previous chapter), toward engineering, or toward gardening—as a customer, he is bound to put constraints on the sculptor.

If he is a "style" architect, he will demand that the sculptor decorate a neo-Gothic church with neo-Gothic motifs and neo-Gothic figures for the recesses (2, 4, 48, 49), or a neo-Baroque bank with neo-Baroque portal sculptures. Commissions of this type were offered, accepted, and carried out by the score, in London, in Paris, in Vienna. Nevertheless, we have great difficulty—perhaps more difficulty than later generations will have—in appreciating this "neo" sculpture. In architecture, a stylistic costume can be merely costume, behind which there is an interesting structure, a significant use of space. But what is left when the stylistic costume is removed from "style sculpture"? The question remains open; later generations may be more capable of answering it.

If, on the other hand, the architect is an engineer or gardener, he will engage the sculptor only to add ornamentation, or at most give him a free hand with certain selected features of the building. Both kinds of commissions can be clearly seen in the World's Fair buildings of London and Paris. There were three features on which the sculptor was usually allowed to collaborate: the artistic adornment of portals and entrance arches (41); the design of fountains and monuments in the gardens (37); and the artistic decoration of the silhouette of halls and domes (41, 45, 56).

In all these cases, it is literally a matter of "artistic adornment"—of embellishing and dressing up, of cosmetic treatment for something that is seen by contemporaries as too

sober or bare or unsightly. It is no wonder that such commissions from engineers or gardeners virtually forced the sculptor into the role of the most superficial kind of decorator; although this is not true in the earlier exhibitions, it is pre-eminently so of those held around 1900 (*45*).

Of the three possibilities for sculpture in the 19th century—architectural, monumental, or independent—it is without doubt the third that offered the sculptor the best chance for development. Like the 19th-century painter, the sculptor of the period only felt his artistic autonomy was respected when the influence of external motivation (the commission) was kept as far away from the work as possible and the inner motivation (creative urge) was allowed to come unhindered into its own. His inner motivation generally led him to create pieces best displayed in museums or in public gardens, for, in the century of museums and exhibitions, art was in the end produced with the museum in mind as the ideal place of permanent rest; the museum was a haven, a purified, protected place, free not only from wind and weather, but also from all external influences, be they sacred or commonplace.

Sculpture failed to gain as prominent a place in 19th-century art as painting. That is why no special terms for phases or tendencies in sculpture have come into circulation. Generally speaking, the vocabulary applied to painting styles can be used to analyze sculpture as well.

Classicism and Romanticism

There is always a temptation to consider Classicism and Romanticism as opposites; chronologically, too, they tend to be separated. But, of course, when the problem is looked at more closely, a rigid division cannot be maintained. Some artists are Romantic in some works and Classicist in others. (The ultimate example might be Schinkel's two dissimilar proposals—one Gothic-Romantic, the other Classical—for the Werder Church, *1, 2*.) The actual historical situation is done more justice by thinking of these concepts as the two outer limits of a pendulum swing. This may help to explain the argument that on one hand the period sought with intensity the traditional values of plastic art, but on the other hand scorned them.

Classicism, in fact, is the only tendency in 19th-century art that granted sculpture, even if only theoretically, a privileged position. The reason is that those revered by the Classicists—the Greeks and Romans—appear to our eyes first and foremost as sculptors (and as architects). Hardly any Classical painting has survived, and vase painting or wall painting cannot be seriously compared with the great Classical sculptures. Moreover, Classical

architecture, especially Greek, is practically synonymous with the idea of plasticity; Greek architecture could indeed be thought of as entirely sculptural.

All this impressed itself so strongly on the Classicists before and after 1800 that their own ambitions ran to highly sculptural expression. But the other half of the pendulum's swing, the Romantic part, was not so happy to accept this unbridled enthusiasm for white marble. For the Romantic, white marble only revealed a tenth part of the soul's burden. Above all, the Romantics felt that color (generally considered to be out of place in sculpture) must come into its own. Moreover, Romanticism exuded a feeling for shadowy depths and twilight moods, which the sculptural medium could hardly capture. Romantic talents, then, mostly chose painting; those with Classical leanings chose sculpture.

The Classicists revived the Roman custom of honoring prominent men and women in portrait busts. The great soldier or politician (Napoleon, *89*), the great poet (Schiller, *93*), the great architect (Gilly, *94*) were depicted as transcending the "spirit of the age"; white marble immortalized them for posterity. (Of the two concepts, "spirit of the age"—*Zeitgeist*—was a new expression, and "posterity"—*Nachwelt*—was a favorite word of this generation.) The solemnity with which the sculptors approached their task precluded the representation of these men in the arbitrary fashions of contemporary life, so they appear either heroically naked (*89, 93*) or dignified by the folds of the Roman toga (*94*). Unlike the realistic Roman portrait, however, their idealized treatment removes them to a spiritual plane.

The Classicists also imbued the tomb with Classical associations. Antonio Canova (1757–1822) placed mourning figures in Greek or Roman dress before the entrance of a small pyramid (*90*). The inclusion of Egyptian architectural features widened the historical reference—a tendency already evident in Piranesi's graphics and firmly adopted by Boullée (*11*). Napoleon's Egyptian campaign of 1798–99 furthered these leanings. Ever since, up to the 20th century, there has been a European tradition of borrowing Egyptian forms and oblique angles, almost exclusively for funerary architecture, such as crematoriums. Egyptian forms, with their tendency to pure geometry, were felt to be appropriate to the rituals of death.

The Classicist sculptor evoked closeness to antiquity; the Romantic sculptor sought proximity to nature. Bertel Thorvaldsen's memorial to the Swiss Guard who fell in the Tuileries, Paris (*99*), is set not in an architectonically created space but in sheer natural rock, over water. It was not the traditional sculptural merits of his monument that made it famous, but its new synthesis of water, rock, and sculpture. The Romantics aspired to precisely this union of diverse elements in a meaningful whole. In general, it was the emotionally charged themes of new beginning, of transformation, and of metamorphosis

89 JEAN-ANTOINE HOUDON (1741–1828), NAPO-
LEON. 1806. Terracotta bust. Musée des Beaux-
Arts, Dijon. Napoleon is represented in the
Roman manner; the "heroic nakedness" of
this Classical bust idealizes the image, while
the imperial gaze, the determined line of mouth
and chin, and the hair falling in unruly, turbu-
lent locks particularize it.

90 ANTONIO CANOVA (1757–1822), TOMB OF THE
ARCHDUCHESS MARIA CHRISTINA. 1798–1805.
Augustinerkirche, Vienna. An early example of
figures derived from the Greek and Roman
tradition combined with borrowings from
Egyptian architecture. The assimilation of
Egyptian forms into the canon of ancient
models continued throughout the 19th century.
It is seen exclusively in tomb monuments and
religious architecture.

91 ANTONIO CANOVA, PAOLINA BORGHESE. 1805.
Marble. Galleria Borghese, Rome. The power
of the Bonapartes is evoked by presentation in
antique style. Paolina, the second sister of
Napoleon I, is idealized in a reclining pose, as
Venus.

92 ANTONIO CANOVA, AMOR AND PSYCHE. 1787–93.
Marble. Louvre, Paris. Tender advances are
portrayed with masterly lightness of compo-
sition. Frontally, the composition is based on
an "X" and a circle, which frame and contain
the gentle twist of the two bodies. Canova
attains a degree of vitality and grace seldom
achieved by the ancient world.

93, 94 JOHANN HEINRICH VON DANNECKER (1758–
1841), FRIEDRICH SCHILLER. 1805–10. Marble
bust. Staatsgalerie, Stuttgart; GOTTFRIED SCHA-
DOW (1764–1850), FRIEDRICH GILLY. 1801.
Marble bust. Nationalgalerie, Berlin. The great
poet and the highly talented architect who died
young are both given distinction by a Classical
presentation, but at the same time, also accord-
ing to Classical canon, they are portrayed as
generalized types, and thus rendered remote
and inaccessible. In fact, the Classicist sculp-
tor's freedom exended only to physiognomical
accuracy; in other respects—carriage of the
head, need for drapery or nudity—he was
severely limited by Classical convention. Any
personal individuality he might bring to his
work can be seen in details only.

95 JEAN-BAPTISTE CARPEAUX (1827–75), THE
DANCE. 1866–69. Stone. Created for the
façade of the opera house, Paris, now in Musée
de l'Opéra. The 19th century shares with the
Middle Ages a feeling for allegory—that is, for
figurative-symbolic representation of general
or abstract concepts (such as Justice, Strength,
Music, Dance). Carpeaux, whose acknowl-
edged master was Rude (*101*), achieved in
Dance a painterly composition of exhilarated
movement that is a far cry from the labored
awkwardness of most allegorical figures.

96 HONORÉ DAUMIER (1808–79), RATAPOIL.
Bronze, from a clay model of c. 1850. 44 cm.
Louvre, Paris. Daumier's "picturesque" clay
statuette served as a model of the boastful and
insolent police informer whom he caricatured
in a number of lithographs around 1850.

97 EDGAR DEGAS (1834–1917), LITTLE BALLERINA.
1880. Bronze and cloth. Ny Carlsberg Glypto-
tek, Copenhagen. Degas was as free from the
sculptural conventions as Daumier. He dressed
his figure in clothes of real material, as though
it were a doll. In doing so he observed one of
the principles of Naturalism—the complete
fusion of alien elements—which, theoretically,
seemed impossible to achieve, but which, in
fact, foreshadows the technique of collage.

98 ADOLF VON HILDEBRAND (1847–1921), FRIENDS.
1909. Clay model. Bayerische Staatsgemälde-
sammlungen, Munich. Hildebrand, a friend of
the noted art historian Heinrich Wölfflin, was
one of the most important theorists of sculp-
ture of his day. His work is infused with this
awareness of theory, but there is no loss of
sensual warmth or naturalness. Here he at-
tempted equanimity with humor, a very rare
combination in sculpture.

UXORI · OPTIMAE
ALBERTVS

90

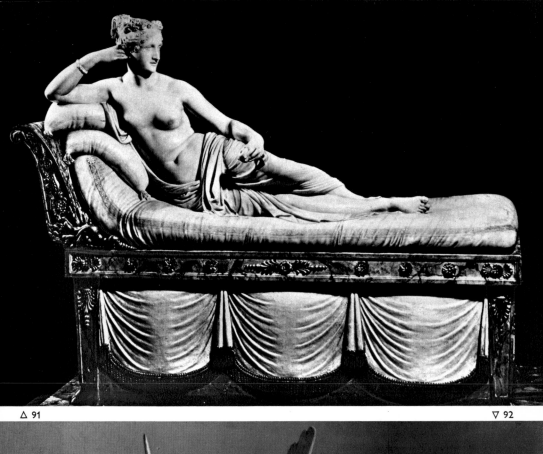

△ 91

▽ 92

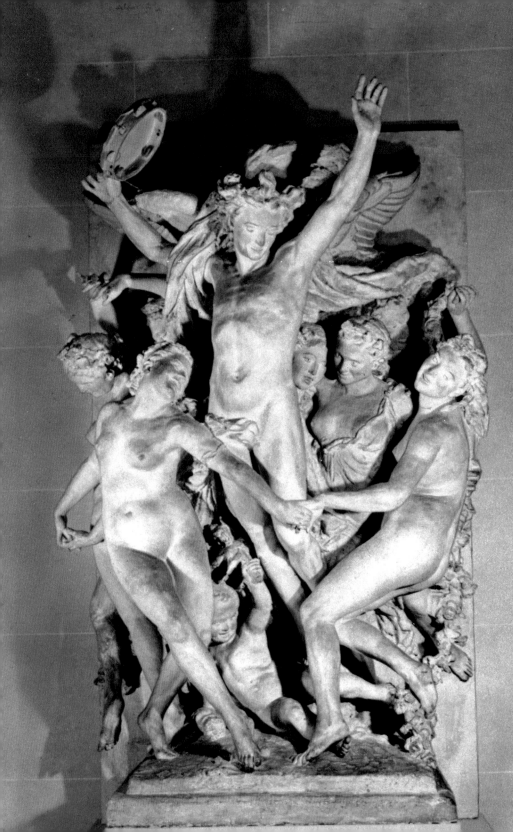

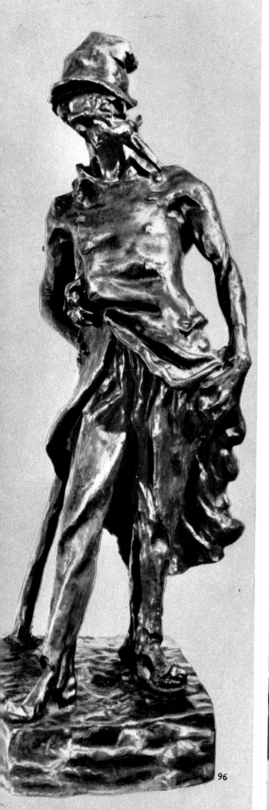

96

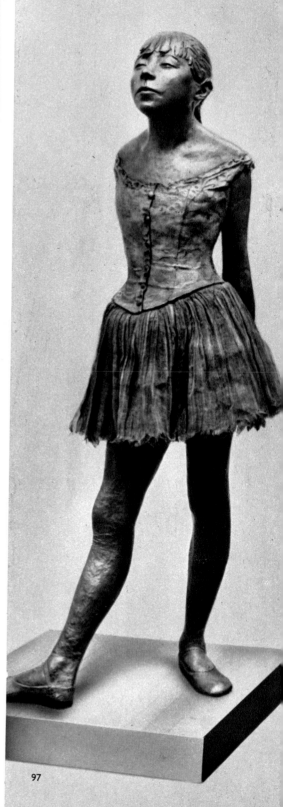

97

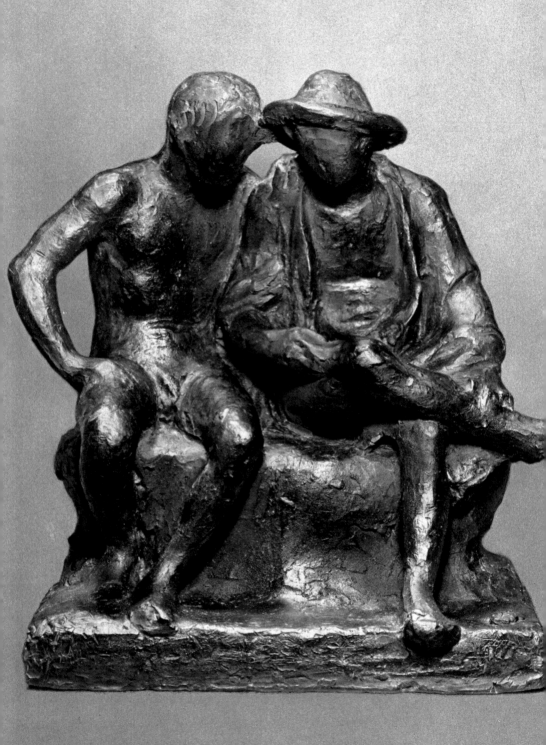

that attracted the Romantic sculptor. François Rude captured, without undue melodrama, a highly charged moment in his relief sculpture *La Marseillaise* (*101*). In the emotional metamorphosis *Napoleon Awakening to Immortality* (*100*), Rude skillfully avoided, on one hand, hollow pathos, and on the other, tastelessness. But is Romantic sculpture not a contradiction in terms, in the sense that an artistic vision of transformation and metamorphosis should not attempt to find expression in the three-dimensional massiveness of stone and bronze? Theoretically this may be the case. But the few real masterpieces of Romantic sculpture show that the contradiction sometimes acted as a challenge to the artist to grasp and to make concrete the limitless and the intangible.

Realism and Impressionism

Can the sculpture of the second half of the century—represented by the work of Jean-Baptiste Carpeaux, Honoré Daumier, Christian Rauch, Edgar Degas, Reinhold Begas, and Auguste Rodin—be considered solely in terms of Realism and Impressionism? These are the most fitting words we have at our disposal. It is clear that, after 1850, the Classical canon was almost totally *passé*. The poles between which sculpture now moved were quite different ones. These poles can be defined as Realism and Impressionism—Realism in the sense of the fresh, unself-conscious employment of themes from ordinary life (*96*), Impressionism in the sense of breaking down surfaces and static sculptural qualities into fluctuating, eye-catching movement (*95, 104, 105*). It is not mere chance that a number of graphic artists now created important sculpture as a sideline. The impact of Daumier or Degas was largely due to the fact that they made no claim to be trained sculptors in the traditional manner. Daumier's *Ratapoil* (*96*) breaks all the rules; symmetry and clear outline go by the board. Degas' *Little Ballerina* (*97*) appears like a doll, dressed up in tutu and ballet shoes. "And why not?" thinks the unprejudiced observer, impressed by the intensity of both works (simply *because* they ignore all the rules).

Among sculptors it was only Auguste Rodin who created the seminal works of the era, evoking all its fears and wishes—indeed, its very essence. The three works illustrated here, *The Thinker* (front of jacket), *The Burghers of Calais* (*104*), and *Balzac* (*105*) can be considered as basic works that do not simply reflect the "spirit of the age" but also reveal its unexpressed desires.

The Thinker is a model for the man who introduced the first Machine Age, as far removed from the philosopher as from the theologican. Instead of seeking distance and detachment, he attacks material problems with a stubbornness that is revealed by his knuckle-biting posture.

The *Burghers of Calais* (*104*) is a monument to a group of citizens who were prepared to sacrifice themselves to raise a murderous siege and save the lives of others. It is a collective martyrdom, then, a 19th-century counterpart to the individual martyr of tradition portrayed in crucifixions.

It is interesting to compare *Balzac* (*105*) with another portrait of a writer, Dannecker's *Schiller* (*93*). The contrast brings out the sheer massiveness and also the evocative power—power through suggestion—of Rodin's work.

In such sculptures Rodin makes us suspend all our conventional notions of good or significant sculpture. His intuitive feeling for correspondences and for a fertile subject and his ability to translate this subject matter into perfect form give the spirit of the epoch shape and substance in a most explicit way.

99 BERTEL THORVALDSEN (1770–1844), LION MONUMENT. 1820–21. Lucerne. Executed by Lukas Ahorn. A Romantic sculpture in which nature becomes a part of the composition and of the artistic effect. Water surface, rock face, and animal sculpture form a "total work" of varied elements.

100, 101 FRANÇOIS RUDE (1784–1855), NAPOLEON AWAKENING TO IMMORTALITY. 1845–47. Bronze. Fixin-lès-Dijon; LA MARSEILLAISE. 1833–36. Stone. Arc de Triomphe, Paris. The Romantic Rude identified himself completely with themes of new beginning or metamorphosis. After the stirring *Marseillaise*, he attempted a far more delicate project, the apotheosis of Napoleon. By a dream-like shrouding of his subject, he succeeded in keeping it within the bounds of good taste.

102 CHRISTIAN DANIEL RAUCH (1777–1857), MONUMENT TO FREDERICK THE GREAT. 1839–51. Potsdam, formerly Berlin. What a gulf separates Gilly's design for a monument to Frederick, drafted in 1797 (*25*), and Rauch's final version of 1851, more than half a century later! Instead of Gilly's great and distant temple we find an equestrian statue of modest and "homey" proportions, richly decorated with detail and totally without revolutionary intent. The popular Prussian king is represented in a monument that is fresh, lively, and spirited.

103 REINHOLD BEGAS (1831–1911), NEPTUNE FOUNTAIN. 1888–91. East Berlin. Neptune on the bank of the Spree evokes visions of excursions and picnics. While Begas' historical antecedents are clearly to be found in Italian Baroque city squares, he attempts here to set something less lofty than an Italian sculpture group to complement the neo-Baroque buildings that had been erected in the German capital.

104 AUGUSTE RODIN (1840–1917), THE BURGHERS OF CALAIS. 1884–86. Bronze. Casts in Calais, London, Basel. The sacrificial procession of a group of Calais citizens who by their sacrifice are able to save the beleaguered town and its population. The theme of a collective martyrdom can be seen as a secularized recapitulation of the crucifixion. Rodin created a "formative image" of 19th-century art, one of the few basic images created in this era by a sculptor rather than a painter. In the name of artistic expression, details are neglected, emphasized, enlarged, or exaggerated.

105 AUGUSTE RODIN, BALZAC. 1897. Bronze. Detail of the upper part of standing figure. Paris, intersection of boulevards Raspail and Montparnasse. The writer is portrayed as inspired sleepwalker or dreamer. He is at once bombastic and sensitive, powerful and childlike. Through dynamic distortion, Rodin is capable of capturing and expressing all these paradoxical elements.

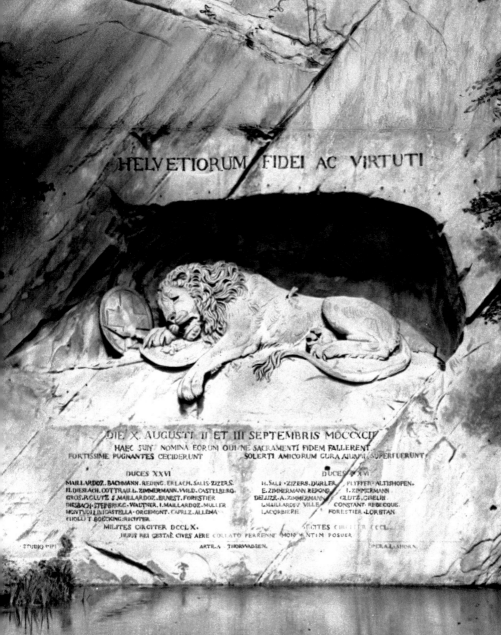

PAINTING

First, two observations that are almost overly obvious: Painting took precedence over sculpture in the 19th century, and in the field of painting, it was the French who dominated.

In the section on sculpture, an attempt was made to show some of the reasons why 19th-century sculpture, in general, lacked life. We now look at the other side of the picture: Why did painting achieve and maintain such an important place?

A variety of answers is possible, but we will confine ourselves here to suggesting only two—one for each half of the century. Around and after 1800, and well into the first decades of the century, a cult of the visual obtained in Classically educated western Europe. (The concept of *Weltanschauung*—"world view"—seems to be a peculiarly German off-shoot of this cult.) One of Goethe's "Maxims" gives it a very clear and economical formu-lation: "Thinking is better than knowing, but not better than seeing." Whatever the histori-cal reasons for the love of observing and watching (from quiet, reflective contemplation to sharp, practical examination), it is certain that only when combined with an intense aware-ness of color did it lead to meaningful expression artistically. And a sense of color, as we have already mentioned, was to a high degree an attribute of the Romantic temperament. The combination of visual orientation with receptiveness to color gave rise to achievements in painting that, in vitality and distinction, compare with the greatest works of earlier epochs.

From the cultural historian's point of view, it is much more difficult to understand why the second half of the century should produce great paintings. The age of technology and of scientific discovery seems at first sight so dominated by calculations and experiments that we hesitate to credit the period with any genuine independent concern for artistic problems, least of all those of painting. But, in fact, it was a technical invention that most strongly influenced the "vision" of the times—its visual perception: this was the invention of photog-raphy. The Introduction pointed out that, among the innovations of the 19th century, discoveries in the fields of information and communication were most important for our present purposes. In the same way that the habits of the eye were fundamentally changed

by the invention of printing about 1450—through the general spread of reading—the development of photography in the 1850s and 1860s radically altered not only the habits of the eye but also optical receptiveness. The effects of early photography and contemporary painting on each other have often been mentioned but rarely taken seriously, because the traditional view is that a "mere" technique like photography could not possibly have influenced one of the fine arts. But the present interest in communication techniques and their inescapable role in our daily lives have opened our eyes to the fact that these connections do exist and can change human perception.

France was recognized in the course of the 19th century as the virtual home of painting, and this still impresses on us today a special respect for the French "genius." The French are supposed to be able to experience "the sensual more spiritually, the spiritual more sensually" than other peoples—a wonderful compliment that would carry even more weight if it did not originate with a Frenchman (Paul Valéry). However, the true reason for France's almost legendary superiority in painting in the 19th century lies in her happy possession of a series of major talents, who appeared in almost unbroken succession. From one generation to the next their names reverberate: from David to Ingres, Delacroix and Corot; to Daumier and Courbet; to Manet, Degas, Monet and Cézanne; to Gauguin and Van Gogh; to Matisse and Braque. They form a chain of giving and taking, of inheritance and enrichment that is unique. No wonder Paris began to see this superior position as almost divinely ordained, and was shaken to the core when the chain broke and the center of gravity began to shift in the 20th century.

For the artist of the 19th century (and the first half of the 20th), it was no joking matter *not* to have been born a Frenchman. But, for all that, non-Frenchmen made a very considerable contribution. What would the century be without Goya and Fuseli (Füssli), without Constable, Turner, the Pre-Raphaelites, without Friedrich, Koch, Runge, Hans von Marées? In fact, these few names have been selected at random; numerous others could be cited. In 1966 the art historian Rudolf Zeitler tried to render a truer account of 19th-century art: he saw it as a European panorama in which not only France, England, and Germany, predictably, were represented, but also, for example, Denmark, Russia, and Italy. Reactions to his attempt to enlarge our vision show that many specialists in 19th-century studies are not yet aware how much they miss by confining their analysis of painting to France and assessing the rest simply as "the rest"—by French criteria, in other words.

In the present brief history of style, in which we are forced to treat the subject in a summary way, the question now arises as to whether a chapter on painting should deal mainly with France, including material on England and Germany, or with Europe. We have to

be content with some kind of compromise: to attempt a truly European survey within these limits would mean dealing with a series of seemingly unconnected fragments.

In describing stylistic manners or tendencies, we shall employ the traditional terms, although on closer inspection, the concepts to which they refer are often not true concepts at all, but simply labels that are more or less apt. Take realism, for example. What is really meant when a movement in art is considered realist? In every age and generation there have been artists who have thought of their work as realistic. It was Gustave Courbet (1819–77) who, in 1855, when his paintings were rejected by the judges for the first Paris World's Fair, hung them in a studio with "Le Réalisme" inscribed over the entrance. If Courbet had not been a truly great painter, this stirring and prophetic self-characterization would have been forgotten long ago. But because it was the war cry of a legitimate struggle for recognition, it eventually became one of the five or six undisputed key terms of the period. From a logical and conceptual point of view, perhaps, it is a vague cliché, but for the art historian, a useful symbol.

Classicism and Romanticism

We enter the century—so conscious of being a century—with three works (*106–8*) by different painters, all concerned with fear, nightmares, or death. Fear and death are in no way sublimated in these works. Neither Goya (1746–1828), nor Fuseli (1741–1825), nor the young David (1748–1825) aimed at sublime, balanced, refined art; that is, they were not, in the narrowest sense, Classicists. And yet the period to which they belong is generally called Classical or Neoclassical.

This was also the era of the French Revolution, and all three of these pictures are concerned with events generated, directly or indirectly, by it. Violence for the sake of political change or reform moved Goya (*The Shooting of the Rebels on 3 May 1808, 106*) and David (*Death of Marat, 108*), gripping them to such an extent that their pictorial language (form and composition) was conditioned by it. Goya abandons any attempt at balance; he veers, visually speaking, between aggression and helpless passivity. David depicts the murder of the revolutionary Marat (who worked in his bath because of a painful skin condition) on a canvas whose upper half is empty; with a memorial plinth that is nothing but a common wooden box; with a bath towel that is transformed before our eyes into a shroud.

Is it going too far to describe both these canvases as reportages? They are indeed significant paintings, but they are also reports of specific historical moments—terse, lurid, reductive—very far from previous painterly ideals of nobility and harmony. They are statements of fact, and everything that the word implies is there: the incident itself, the

background documentation, the graphic immediacy. A new genre of painting has been created. Here at this early date is realism, long before Courbet and in a much stricter sense than any Courbet conceived.

An interesting fact about Goya is that it was he, a Spaniard not a Frenchman, who first adequately recorded the French Revolution and its consequences. "Seismically" notating this event in his drawings and paintings, he was sensitive to the most shocking as well as the most delicate tremors.

106 FRANCISCO JOSÉ DE GOYA Y LUCIENTES (1746–1828), THE SHOOTING OF THE REBELS ON 3 MAY 1808. 1814. Detail. Prado, Madrid. Goya, Goethe's contemporary, relentlessly recorded the more sinister aspects of his age, particularly its cruelty and greed. Chronologically, he belongs to the early generation of Classicists, who were destined to experience not harmony in society but revolution.

107 JOHANN HEINRICH FUSELI (1741–1825), THE NIGHTMARE. 1782–83. Goethe-Museum, Frankfurt. The Swiss Fuseli (born Füssli), after emigrating to England, made his mark with a style of painting in which he relied little on color, and to a great extent on novel subject matter, dramatic movement, and demonic contrasts of light and dark. With his contemporaries Goya and David, he can be considered what might be called a "revolutionary Classicist."

108 JACQUES-LOUIS DAVID (1748–1825), DEATH OF MARAT. 1793. Detail. Musées Royaux des Beaux-Arts, Brussels. One of the greatest artistic products of the French Revolution: powerful reportage that is at the same time an immaculately composed work of art.

109 JACQUES-LOUIS DAVID, THE OATH OF THE HORATII. 1784. Louvre, Paris. A didactic picture dating from the years immediately before the outbreak of the French Revolution. The concept of the struggle for political justice is expressed by evoking Roman ideals, which were greatly admired at the time.

110 BARON ANTOINE-JEAN GROS (1771–1835), BONAPARTE WITH THE PLAGUE VICTIMS OF JAFFA. 1804. Louvre, Paris. Gros borrowed the composition, gesture vocabulary, and emotional tone of traditional history painting (whose subject matter was usually an event from the distant past or from mythology) for a scene of immediate political relevance. He treats Napoleon like a hero from another age, glorifying him by transforming one of his deeds into an act of charity.

111, 112 THÉODORE GÉRICAULT (1791–1824), RAFT OF THE MEDUSA. 1818. Louvre, Paris; EUGÈNE DELACROIX (1798–1863), DANTE AND VIRGIL CROSSING THE STYX (also called DANTE AND VIRGIL IN HELL). 1822. Louvre, Paris. The themes of danger on the high seas and shipwreck were favorites of the time. It is interesting to speculate whether they reflect not only a basic feeling of political insecurity, but also perhaps the threat posed by the "advances" of civilization.

113 EUGÈNE DELACROIX, WOMAN WITH A PARROT. 1827. Musée des Beaux-Arts, Lyons. Delacroix attains a new subtlety in color value, developed in what is for him a somewhat rare subject, in that it is entirely free of emotional overtones. Here he conveys enchanted peace, relaxation, and composure.

114 CHARLES-GABRIEL GLEYRE (1806–74), PENTHEUS PURSUED BY THE MAENADS. 1864. Kunstmuseum, Basel. The work shows that a painting with stock Romantic ingredients (flight, transformation, metamorphosis) was considered viable even beyond the middle of the century.

115 JEAN-AUGUSTE-DOMINIQUE INGRES (1780–1867), APOTHEOSIS OF HOMER. 1827. Louvre, Paris. Classicism in the narrowest, purest sense of the word: symmetry, seriousness of purpose, lofty values, restrained emotion.

1C

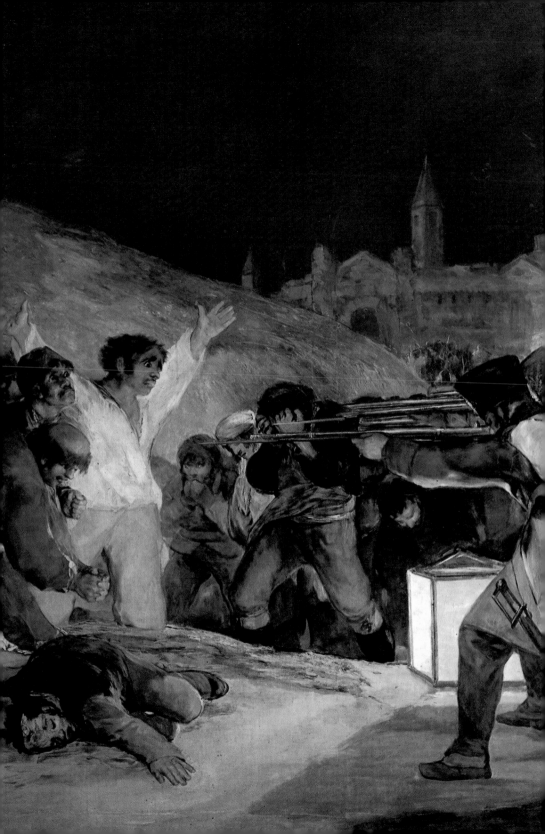

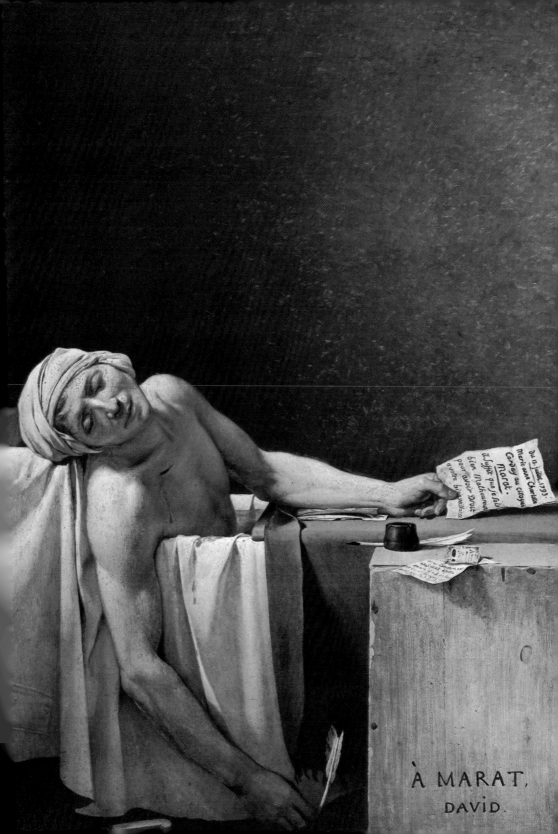

Du 13. Juillet, 1793.
Marie anne Charlotte
Corday au citoyen
Marat.
il suffit que je sois
bien Malheureuse
pour avoir Droit
à votre bienveillance

À MARAT.
DAVID.

△ 109

▽ 110

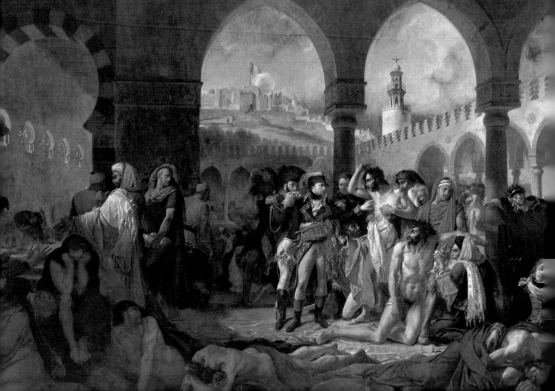

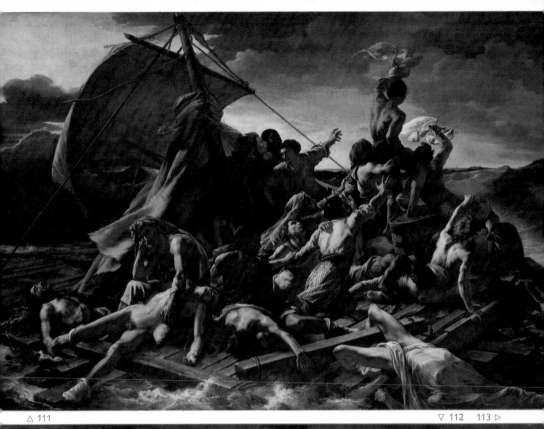

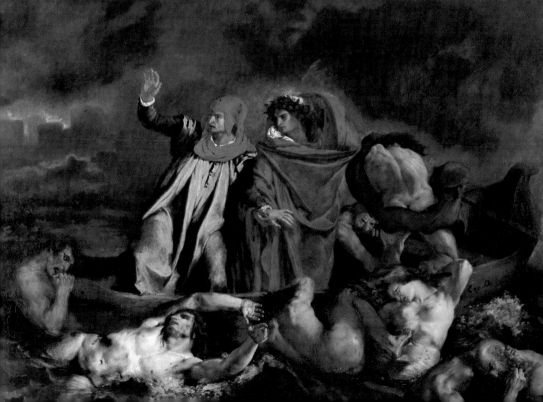

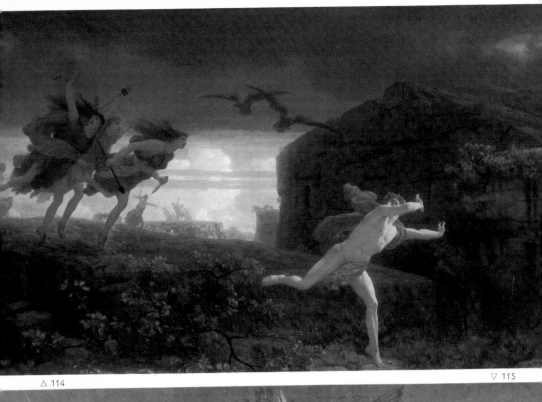

The swing of the pendulum between Classicism and Romanticism, which we also noted in sculpture, did not reach a climax in painting until the generation after Goya and David. The two poles are represented in the work of the Classicist Ingres (1780–1867) and the Romantic Delacroix (1798–1863). Comparing the *Apotheosis of Homer* (*115*) by Ingres with Delacroix's *Dante and Virgil Crossing the Styx* (*112*), we might almost say that every brushstroke, every accent, and every line of composition are conditioned by opposing points of view. Ingres' powerful calm and Delacroix's powerful mobility are only one set of contrasts. There are others: for Ingres, symmetry, solemnity, dignity, deliberation, and control are guidelines; for Delacroix, asymmetry, passionate turmoil, emotional out-pourings of suffering and joy. In sum, and greatly oversimplifying the matter, one might say that Ingres, in the last analysis, is a master of form, Delacroix a master of color. (Natu-rally such a generalization is far too schematic, and is refuted, in details, by the works themselves.) In his *Woman with a Parrot* (*113*), for example, Delacroix, atypically, was attracted by a wonderfully relaxed, even lethargic, female figure. Broadly speaking, how-ever, there is a world of difference between Ingres' and Delacroix's nudes. For Delacroix, paint is a paste, a substance with depth of its own; it is an independent and absolute power, free of subservience to form.

Can we find a similar polarization in German painting? The answer is less clear cut; Germany produced, in Johann Joachim Winckelmann (1717–68), one of the greatest theoreticians of Classicism, but no great Classicist painter. Joseph Anton Koch's work (*Heroic Landscape, 122*) derives, with some loss of power, from the Classical "heroic" landscape in the sense of Claude Lorrain and Nicolas Poussin, but the true line of develop-ment from Claude's great syntheses of nature and architecture really lay in Piranesi's architectural landscapes. Koch's would-be grand landscape, by contrast, is often merely an inflated landscape.

At the other pole, however, we find Caspar David Friedrich (*Chalk Cliffs on Rügen Island, 124*; see also *119*) and Philipp Otto Runge (*The Hülsenbeck Children, 125*), two Romantic painters of outstanding quality. By the standards of French art theory, they both push against or even venture beyond the accepted limits of painting. Their way of feeling and thinking is quite different from the French school; the literary and philosophical theories of their time were more important to them than theories of art in the narrow sense. Fried-rich (1774–1840) is an "intellectual painter," expressing a highly cerebral "world view" in paint (much as Böcklin would later). His approach led him to produce symbolist works of a quality as high, from a painterly viewpoint, as the frankly visual works created by the less reflective and less meditative French temperament of the day. It is rare to find any-where such a remarkable concord of idea and visual means as in Friedrich's *Chalk Cliffs*

on Rügen Island (124). Similarly, Runge's children's portrait (*125*) is more than a charming picture of youthful play. It evokes the awakening or "dawn" of mankind; this is not simply an excess of intellectualism, but an attempt to capture the magic freshness of the primal world. The attempt ended all too soon, for Runge's life (1777–1810) was destined to be as short as those of the writer Novalis (1772–1801) and the architect Gilly (1772–1800). In rank he is the Novalis or Gilly of German painting.

116 CARL SPITZWEG (1808–85), THE POOR POET. 1839. Neue Pinakothek, Munich. The conflict between the flight of poetic fancy and everyday reality is rendered in all its precariousness. The artist, of the so-called Biedermeyer tendency (homey, unsophisticated, anecdotal—the antithesis of lofty idealism or high tragedy), also has a sense of humor.

117 MORITZ VON SCHWIND (1804–71), EARLY MORNING. 1858. Hessisches Landesmuseum, Darmstadt. This is a late version of the "window theme," which played an important part in German painting (see *118, 119*). Here it is imbued with Biedermeyer freshness and cheer.

118, 119 ADOLPH VON MENZEL (1815–1905), ROOM WITH A BALCONY. Nationalgalerie, Berlin; GEORG FRIEDRICH KERSTING (1785–1847), CASPAR DAVID FRIEDRICH IN HIS STUDIO. 1819. Kunsthalle, Hamburg. The "window theme" is seen by two different generations. The monastic bareness of Kersting's room contributes greatly to a very effective "total portrait" of the intellectual painter C. D. Friedrich. Menzel's study, precisely because it completely lacks pretension, is appealingly sincere.

120 JEAN-BAPTISTE-CAMILLE COROT (1796–1875), CHARTRES CATHEDRAL. 1830. Louvre, Paris. The master of the "miniature" landscape turns to the great cathedral, keeping a respectful distance by placing stones, a hillock, and a tree in the foreground.

121 JOHN CONSTABLE (1776–1837), THE CORNFIELD. 1826. National Gallery, London. Of the English painters, Constable is closest to Corot and Delacroix. In his choice of subjects, he is restrained and often lyrical like Corot; but his colors, emphatic and thickly applied, are more akin to those of Delacroix.

122 JOSEPH ANTON KOCH (1768–1839), HEROIC LANDSCAPE WITH RAINBOW. 1805. Staatliche Kunsthalle, Karlsruhe. Koch sought to revive for the 19th century the great 17th-century tradition of the heroic—that is, Classical and idealized—landscape, as perfected by Nicolas Poussin. It is informative to compare contemporary utopian architectural designs (*11, 25*).

123 LUDWIG RICHTER (1803–84), CROSSING THE ELBE AT SCHRECKENSTEIN NEAR AUSSIG. 1837. Gemäldegalerie, Dresden. The introspective mood of this evening crossing achieves a tone of irresolution between the familiar and the marvelous—an antithesis that is particularly important in German Romanticism. Solid draftsmanship is clearly the substantive basis of the composition; the paint is transparent glaze, quite different from the thick and passionate application of the French Romantics (*111, 112*).

124 CASPAR DAVID FRIEDRICH (1774–1840), CHALK CLIFFS ON RÜGEN ISLAND. 1818. Stiftung Oskar Reinhart, Winterthur. The theme of the serene yet fearful view into the depths corresponds perfectly to Friedrich's intellectual preoccupations: implied meaning is mirrored by sensory phenomena.

125 PHILIPP OTTO RUNGE (1777–1810), THE HÜLSENBECK CHILDREN. 1805–6. Detail. Kunsthalle, Hamburg. On the surface, the painting shows childrens' games in an enclosed and domesticated bourgeois garden, but Runge, the outstanding exponent of German Romanticism, has flooded the scene with an enchanted, radiant morning light, thus conveying his idea that this portrait of everyday life is, on another level, an evocation of primal innocence.

△ 122

▽ 123 124 ▷

Realism and Idealism

Courbet's *Stonebreakers* (*128*), Daumier's *Washerwoman* (*127*), and Millet's *Gleaners* (*129*) all deal with realistic themes—with the everyday life of workers who have never heard of Classical mythology and are just as far from the Romantic dream or passion. But no painter is ever completely restricted by his subject matter, least of all the 19th-century painter. Thus each—Courbet (1819–77), Daumier (1808–79), and Millet (1814–75)—portrays a different reality. In Daumier's back-lit painting, which renders the foreground figures almost as silhouettes, there is a very restrained form of social criticism, which is particularly apparent if one knows the artist's drawings. For Daumier's cartoons, published in Parisian journals, are a splendid moral and political commentary on life in a 19th-century metropolis. He mercilessly contrasted the righteous with the unrighteous, speculation with honesty, arrogance with helplessness; his life's work was devoted to the cause of social justice. And as a painter, too, Daumier could not suppress his commitment. He managed to give to his humble subjects a weight and dignity previously reserved for more elevated themes.

Jean-François Millet's view of reality is quite different: for him the lowly peasant woman working her fields was a picture of pious activity, performing a kind of act of faith through work. Her silent labor was for the good of the community. Coming as it does in mid-century (1857), Millet's association of work and piety had an anachronistic quality, for the first Machine Age was already under way, with its tendency to examine the concept of labor and to divorce it completely from religious and ethical associations. A debate was raging, concerned with nothing less than the meaning of work. It is not surprising that in the next generation it was particularly Vincent Van Gogh, with his affinity for the soil and growing things, who most greatly admired Millet's work.

Gustave Courbet was much closer to Daumier than to Millet. He was concerned not with the sanctity of labor but with justice and social criticism. But basically, however much he saw himself in this role, he was not a critic of society or a political campaigner but a painter of life through and through, an unrestrained admirer of the glory of vitality and the life force. So it is that his *Stonebreakers* (*128*) are simply hard workers without any social or religious overtones, men who can do something and take a natural pride in doing it. Courbet's favorite themes are found where vitality is directly expressed: trees, fruit, women, and waves are the four motifs that inspired his greatest achievements. Courbet had a quite primitive capacity for awe at the power of nature. A mighty tree or a voluptuous woman aroused in him the deepest conviction of the permanence and procreative continuity of life: His works are the finest and most vital praise of creation the 19th century produced.

129

With a sure instinct, Courbet knew how to marry his favorite subjects: the tree and the woman are combined in *Sleeping Woman by a Stream* (*126*). He produced many variations on the theme of the woman in the forest. He saw female figures as strangely calm, slow, even lethargic, creatures: On every level, he glorified the organic, vegetative spirit, rejecting the conscious and the intellectual. It is perhaps not surprising that Courbet found a last great inspiration in the sea wave. He painted waves like women's bodies: as a promise of "the eternal recurrence" (if we can apply to Courbet a later, Nietzschean, 19th-century concept).

Undoubtedly, Courbet, with his hymn to organic life, had discovered a "basic" reality; that is to say, of all the possible levels of realism, he hit upon and formulated the one that is in fact—from a biological point of view—the basis on which all life rests. We might ask whether the same claim could be made for the Swiss Robert Zünd (1827–1909; *Group of Trees, 131*) or the Rhinelander Wilhelm Leibl (1844–1900; *Three Women in Church, 132*), as well as for other artists of similar tendencies, for instance Hans Thoma or Wilhelm Trübner. Zünd and Leibl depart significantly from Courbet in their preference for punctilious detail. In Zünd's case it is precisely this—to the point of pedantry—that robs him of a free and completely convincing formulation of organic power. The same is true of Leibl, although he was strongly influenced by Courbet in his Paris years (1869–70), when his brushwork appears spontaneous and free. Later, however, he became obsessed by a search for "truth" that exalted detail above all else. *Three Women in Church* (*132*) is an illustration of this; a highly talented and serious painter devotes his best energies to "nailing down" optical, specific truth, is oblivious to larger, more general statements, and is threatened with loss of inspiration.

Where can truth be found? On the surface (in visual "sign language")? In depth (through the inspired rhythm of the brush)? Or "hidden beneath the skin"? All the artists mentioned, from Courbet to Leibl, worked expressly on this question or with this question in mind.

A powerful intellectual movement of the time, inspired by philosophy but influencing literature and the arts, maintained that the reality around us is mere appearance and that the real world never truly reveals itself in this visible appearance, but at most is manifested as a shadowy reflection in it. This must be so since the idea, as the foundation of all truth, remains concealed behind visible appearance.

This doctrine—ultimately, of course, derived from Plato, and constantly recurring in both medieval and modern Europe—was redefined in the ardent idealism of the 19th-century German philosophers Fichte, Schelling, and Hegel. It was naturally the German-speaking areas that were most strongly affected by this German idealism, as it is called. German literature and painting both bear the stamp of idealistic philosophy.

Philosophy is closely related to literature in most cultures (both express themselves in words), but the same relationship is not so obvious in the case of the visual arts, if only because they are expressly non-verbal. Such a relationship did exist in 19th-century Germany, however, although it is difficult to cite concrete examples, since a certain prismatic distortion occurs in translation from one medium to another (words into images). One instance is Anselm Feuerbach's (1829–80) *Memory of Tivoli* (*135*). Significantly, it is called a "memory"—that is, not a directly received impression. Two children are seen in an Italian landscape, singing and musing. Do children do this? And, if so, do they do it in this way? No, these are idealized children, ennobled creatures meant to create harmony around them, perhaps "the unison of Nature and Song" (the vagueness of my formulation here shows how vague Feuerbach's meaning or allusions have become for us).

This kind of painting strives to erect a bridge between idea and appearance, while, however, constantly questioning whether the appearance is a reliable representation of the idea. Such doubts, so the usual explanation has it, are merely typical of the Northern lack of confidence; Latins, in their more instinctual existence, are not plagued by the possible discrepancy between idea and appearance. But simplifications of this kind simply do not stand up. Italy, too, produced idealistic painting, and in France Millet and Pierre Puvis de Chavannes (1824–98) can at the very least be said to be idealizing painters, if not idealists. The division between idealistic mistrust of appearance and spontaneous sensuous acceptance of appearance is not, then, a simple North-South one. It crisscrosses the whole field of 19th-century painting. Often the conflicting strains are found in the single individual, obliged to confess (with Goethe's Faust) that two souls dwell within his breast. An almost classical example of the dichotomy is seen in Arnold Böcklin's (1827–1901) pictures *Naiads at Play* (*133*) and *The Isle of the Dead* (*134*). *The Isle of the Dead* is a scene that the artist has never laid eyes on, and he is not at all sure that it really exists, whereas his naiads, while fictitious, exist most definitely in the concrete world of sensuous appearance, even though set among the mythological scenery appropriate to the expectations of Böcklin's Classically educated public. The comparison reveals Böcklin's essential qualities: He is a magnificently vital visual power, robbed of spontaneity both by idealistic mistrust of appearance and by obligations toward Classical learning.

Impressionists and Pre-Raphaelites

The dichotomy between realists and idealists—a European phenomenon sharply pointed up by the French-German polarity—is seen at its most exaggerated in the works of the French Impressionists and English Pre-Raphaelites.

Once again, division along strictly nationalistic lines is misleading, as the example of William Turner (1775–1851; *The Burning of the Houses of Parliament, 137*) shows. For the Englishman Turner is the true predecessor of the Impressionists, though born almost two generations earlier. In evolving his "mood landscapes" he began depicting not objects themselves but the impression they create in a certain light.

The problem of "truth" already touched on—of whether it lies on the (visual) surface or in depth—was treated in a surprising and novel way by the Impressionists. They transferred the problem from the object to the seeing, perceiving eye.

126 GUSTAVE COURBET (1819–77), SLEEPING WOMAN BY A STREAM. 1868. Stiftung Oskar Reinhart, Winterthur. Courbet glorifies the woman as life giver and embodiment of the life force. Water and forest surround her, as attributes of the fullness of regeneration.

127–29 HONORÉ DAUMIER, THE WASHERWOMAN. c. 1863. Louvre, Paris; GUSTAVE COURBET, THE STONEBREAKERS. 1849. Destroyed 1945 (formerly Gemäldegalerie, Dresden); JEAN-FRANÇOIS MILLET (1814–75), THE GLEANERS. 1857. Louvre, Paris. Social problems were treated by painters from about 1850 on. These three works represented to the eyes of their contemporaries a new kind of subject: they gave significance to mundane, anonymous activities and at the same time raised for discussion the social question of the living conditions of peasants and workers.

130 ADOLPH VON MENZEL, ROLLING MILL. 1875. Staatliche Museen, Nationalgalerie, East Berlin. In showing the industrialization and proletarization of a former craft occupation, Menzel reports the general atmosphere in a factual manner, without dwelling on the situation of any one individual.

131, 132 ROBERT ZÜND (1827–1909), GROUP OF TREES NEAR LUCERNE. Undated. Kunstmuseum, Basel; WILHELM LEIBL (1844–1900), THREE WOMEN IN CHURCH. 1882. Kunsthalle, Hamburg. What brings Leibl and Zünd together, despite their differing subject matter, is their tendency to realize the truth in a fastidious account of detail.

133, 134 ARNOLD BÖCKLIN (1827–1901), NAIADS AT PLAY. 1886. Kunstmuseum, Basel; THE ISLE OF THE DEAD (first version). 1880. Kunstmuseum, Basel, Gottfried-Keller-Stiftung. These paintings represent two poles in Böcklin's work. His sharply defined image of death is highly idealistic and responds to the humanist background of his Classically educated generation. The theme of the naiads allows him to portray the exuberance of life, with mythological scenery providing the requisite lofty pretext.

135 ANSELM FEUERBACH (1829–80), MEMORY OF TIVOLI. 1867. Nationalgalerie, Berlin. Feuerbach has attempted to give visual form to German idealism. His theme is the harmony of music, song, and landscape, but this concept can only be evoked, never concretely demonstrated, because the essence of music cannot be captured in paint, and least of all in a literal representation of the real world.

136 HANS VON MARÉES (1837–87), DIANA BATHING. 1863. Detail. Haus der Kunst, Munich. Marées occupies roughly the same position in German painting as Hildebrand (*98*) in sculpture. Both were highly cultivated and interested in theory, but sought to strike a balance between sensuousness and intellect. Marées is the most "painterly" among the German painters of his generation—that is, what takes shape on his canvas arises primarily and genuinely out of his feeling for paint: form proceeds from color. In his hands, paint is a somber-toned, dense material.

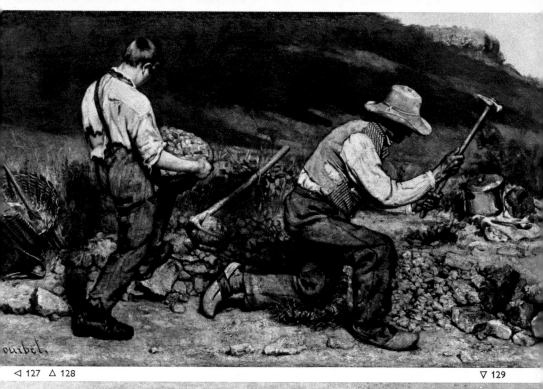

◁ 127 △ 128

▽ 129

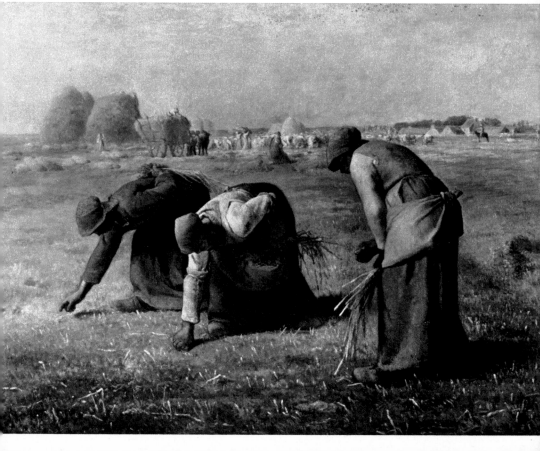

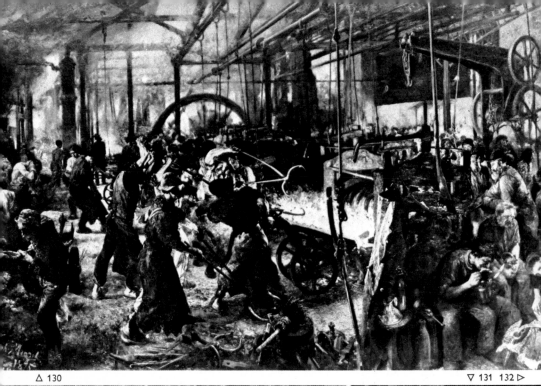

△ 130 ▽ 131 132 ▷

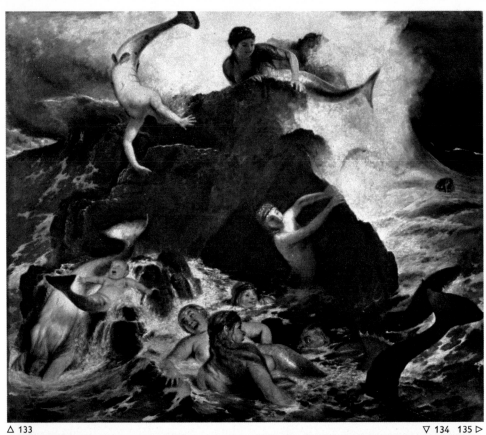

△ 133 ▽ 134 135 ▷

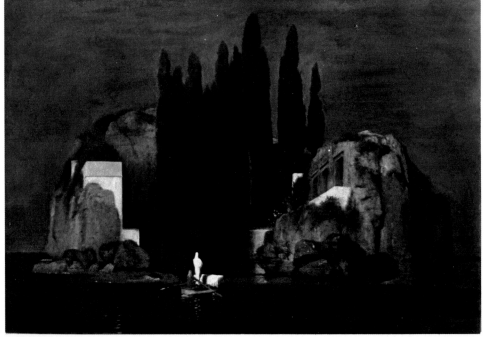

Our vision, whether we are artists or not, is indeed subject to very specific laws of optics, and optics as a branch of science made great strides in the second half of the 19th century. With optics "in the air," it was natural that visual art should be influenced by its color laws. The question of truth received from the Impressionists a very unidealistic and scientific answer: all appearances are true that lie within a (light-wave) range to which the human eye is able to respond.

The Impressionists were the first generation of painters to treat the eye as an instrument— as an apparatus—and to take its strengths and weaknesses consciously into account. There were two chief results. In the first place, they broke down mixed colors into their primary tones and communicated them in this way to the eye. Thus the eye itself does the mixing, and hence the quite unique freshness of the Impressionists' color effects. (It should be remembered, though, that individual artists handled this technique of color separation in a variety of ways and degrees—no real principle was established until Georges Seurat [1859–91] introduced his Pointillism; *147*.) Secondly, in scientific spirit, they considered the eye as an impartial instrument, receptive to colors, lines, and dots, but in no way judging what it sees, either morally or by any other criteria. The Impressionists' aim is to be only an eye, and for them the highest praise was: "Seulement un oeil, mais quel oeil!" ("Only an eye, but what an eye!")

In line with these two tenets, the Impressionist artist looked for particular subject matter: it must have potential for exploitation of color and light; and it must be as far as possible neutral and impartial, having nothing to do with the old scale of values, either religious or social. For Claude Monet, for example, an appropriate subject was the Gare St-Lazare (*138*), a new building at the time and therefore free of traditional preconceptions, seen as a secular "study of morning." The artist was obviously drawn to the power and splendor of the new form of transport, but he was elated even more by his experience of color, particularly by his exploration of color where previously none would have been expected or noticed. The cloud billowing forth from the locomotive, bluish in the shadow of the station, white in the open light, is the main theme. The purely visual is the true basis of this art, possible precisely *because* no meaning is implied. (We must guard against too sweeping a statement here; of course, Monet's fascination with the subject matter implies the presence of some value judgment.)

Above all, the Impressionists liked to leave the city behind and go out to the banks of the Seine and the shores of little lakes and ponds where people were engaged in rowing or sailing. They were attracted by sport, in other words, particularly by new forms of recreation imported from England (complete with English technical expressions). Nearly every Impressionist—Edouard Manet, Claude Monet, Pierre-Auguste Renoir, Camille Pissarro,

Alfred Sisley—painted boating scenes more than once (*139, 141, 143*). To Sisley, indeed, even a flood (*142*) was a kind of festive occasion, for in purely visual terms it is an intensification of light, and the great sheet of water provides a vast surface area acting like a mirror to reflect color. Only Edgar Degas (1834–1917) remained aloof from these subjects. It was not the picturesque suburbs, river banks, water, or boating that attracted him, but the metropolis itself (*146*), with its theaters and its ballet. Outside the city, he preferred turf to water, horse-racing to boating.

The Impressionists as a group were unique: of all the 19th-century groups with new theories, from the German Nazarenes to the French Barbizon School, from the English Pre-Raphaelites to the alliances and secession movements of Art Nouveau, none was so closely bound together by truly innovatory principles as the Impressionists and yet none so effective in allowing free development to individual members. England put forth the most distinctive challenge to the superiority of French Impressionism. If we followed British usage we would call this challenge simply Victorian painting, but the custom of naming periods after monarchs is obsolete (surviving only in England itself), and, in addition, Queen Victoria's reign was too long (1837–1901) to offer any but the vaguest definition.

With England at the height of its power as the leading colonial and industrial nation, ahead of the world in technical invention, it is quite understandable that there was a bitter reaction to the machine and to the values of the new industrial society. A group of artists revolted, championing poverty and humility in the face of imperialism, assessing technology and science sceptically or pejoratively, and seeking to return to a kind of "natural" life.

It is significant that this group first called themselves Early Christians, before becoming known as the Pre-Raphaelite Brotherhood. They were a "group of brothers," then (like their forerunners, the German Nazarenes, among whom were Johann Friedrich Overbeck, Franz Pforr and, after 1811, Peter Cornelius, Gottfried Schadow, and Julius Schnorr von Carolsfeld), who drew their inspiration from "pure" early sources, generally from before the Renaissance, and specifically from before the followers of Raphael, or Raphaelites. The brotherhood was founded by Sir John Everett Millais (*151*), William Holman Hunt, Dante Gabriel Rossetti, and the poet William Rossetti, who were later joined by Thomas Woolner, James Collinson, and Frederick George Stephens. Two other artists who were loosely associated with the group, Sir Edward Burne-Jones (*150*) and the social reformer William Morris (1834–96), are usually assigned to it today.

The brief existence of the Pre-Raphaelite Brotherhood (it was inaugurated in 1848, and the members drifted apart a few years later) does not at first sight seem to justify any comparison with the Impressionists (who began forming around Manet from 1863 on, and did not hold their first group show until 1874). But the Pre-Raphaelites were much

more than a short-lived group: they were the initiators of a long-lasting and productive movement in painting, and they also engendered violent controversy over esthetics. Beginning in 1851, their spokesman was John Ruskin (1819–1900).

The two examples illustrated are taken from the beginning and end of the movement. Millais' (1829–96) work is dated 1852 (*151*), Burne-Jones' (1833–98) was painted in 1884 (*150*); yet their styles could easily be contemporaneous. Because the Pre-Raphaelites advocated a return to the Early Renaissance, their techniques, color-range, and composition were consciously conservative, removed as far as possible from the century's lust for progress. They ignored or failed to register the chief principles of Impressionism: separation of color according to the laws of optics and exclusion of religious and social value judgments.

A Pre-Raphaelite theme like *Ophelia* (*151*) is "literary," in that it is associated with a classic literary work, and it is cerebral—remembered but not seen—presupposing some knowledge of the literary allusions (French critics would have objected to it on just these grounds). The very title of such a subject as *King Cophetua and the Beggar Maid* (*150*) identifies it as a product of the traditional social hierarchy.

To be sure, works of this kind had far less influence on the 20th century than those of the Impressionists. But with increasing historical distance, there is today a new interest in re-examining their qualities and in recognizing in this art a manifestation of a broad current flowing through the second half of the century. The current was not without its important representatives in France, as a work by Gustave Moreau (1826–98; *The Dance of Salome*, *149*) demonstrates.

Expressionism and Symbolism

It is with much less confidence that we introduce this last pair of contrasting terms, which refer to the generation that received and developed the heritage of the Impressionists and Pre-Raphaelites. The concept of Expressionism can be applied with as much justice to movements in 20th-century art. And, although Van Gogh, Edvard Munch, and Gauguin, for example, obviously painted "expressively," it might be worth considering a term like "exoticism" for Gauguin and Rousseau. As soon as major artists assert their independence and reject groups and factions, critical search for a common denominator becomes a very difficult business.

This applies especially to the great individualists who rose to fame during the last phases of the century. Paul Cézanne (1839–1906), Henri "Douanier" Rousseau (1844–1910), Paul Gauguin (1848–1903), Vincent Van Gogh (1853–90), and Ferdinand Hodler (1853–1918)

have been singled out for mention here, because their work exerted a formative influence—though not an exclusive one—on the last decade and a half before 1900. None of them will fit neatly into categories or groups. How true this is can be seen from a comparison of four self-portraits, by Cézanne, Hodler, Van Gogh, and Gauguin (155–58), and a portrait by Rousseau (154). Personalities speak to us here who, to a very unusual degree, are isolated individuals. For this reason, short descriptions of each artist will follow, with no claim to do complete justice to the quality of these masters, almost all of whom left a powerful stamp on the art of the early 20th century.

137 JOSEPH MALLORD WILLIAM TURNER (1775–1851), THE BURNING OF THE HOUSES OF PARLIAMENT. 1835. Detail. Museum of Art, Cleveland, Ohio. The great fire is painted as an "impression," described as an optical event with completely new methods: the painting is constructed with color and light alone. There is a conscious audacity in the vagueness of outline and the blurring of details, which appear as "negative" values. Turner executed this and a large number of other canvases, in which he sought to capture light and atmosphere, a whole generation before the Impressionists in France adopted similar means.

138 CLAUDE MONET (1840–1926), GARE ST-LAZARE. 1877. Fogg Art Museum, Cambridge, Mass. Railroad tracks, stations, and steam locomotives were fascinating products of technical progress. But Monet's attraction to the subject is not naive. With this prosaic theme he deliberately challenges high art: the subject is merely a starting point for a color study that is as subtly variegated as it is powerful. It is a rare case of great art inspired by contemporary industrialization.

139–42 PIERRE-AUGUSTE RENOIR (1841–1919), LUNCHEON OF THE BOATING PARTY. 1881. Phillips Collection, Washington, D. C.; CAMILLE PISSARRO (1830–1903), COACH, LOUVECIENNES. 1870. Louvre, Paris; ÉDOUARD MANET (1832–83), THE BOAT. 1874. Neue Pinakothek, Munich; ALFRED SISLEY (1839–99), THE FLOOD. 1876. Louvre, Paris. The Impressionists achieved common or related results because, starting with shared convictions (above all concerning the laws of optics), they arrived at similar new subject matter. Their pictures are often sketches, only relatively complete or finished, constructed without reference to the conventional scale of values. They sought consistently to intensify color into light itself, hence their preference for calm, mirror-like water that allows reflections. They sought also to capture the passing moment permanently.

143 PIERRE-AUGUSTE RENOIR, LA GRENOUILLÈRE. 1869. Nationalmuseum, Stockholm. La Grenouillère was a meeting place of sportsmen and strollers at the edge of Paris. The gently rippling waves are rendered by strokes of color; at the same time the water reflects the sky. This double effect of light and color is observed and captured in such a way that each intensifies the other—creating the sparkling interaction that is so characteristic of Impressionism.

144 CLAUDE MONET, WATER LILIES. 1904. Detail. G. Bührle Collection, Zurich. The water lily, a blossoming ship on the water, is the chief subject of Monet's last years. For him it is the simplest subject, the common denominator of everything his painting glorifies: color, reflected light, forms floating and suspended. He considered these late works as parts of a continuous and "open-ended" whole; in this, they are reminiscent of Japanese art, and also anticipate an important principle of 20th-century art.

144

△ 139 ▽ 140

△ 141 ▽ 142 143 ▷

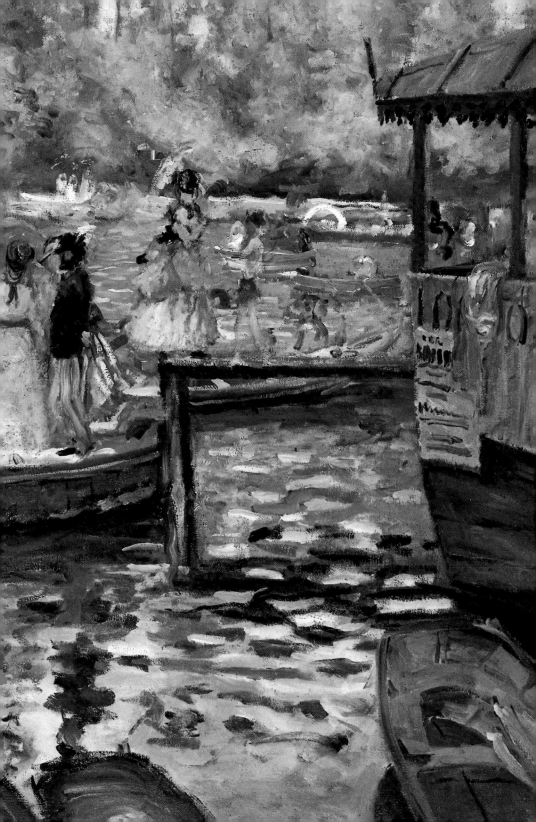

Paul Cézanne (*155, 160, 161*) was odd man out among the Impressionists and does not readily fit into the Paris group. He returned to his home in southern France, where he executed in comparative seclusion a body of work that slowly crystallized and ultimately proved to be one of the greatest achievements of the *fin de siècle*. Where the Impressionists had primarily related their discovery of the laws of optics to the function of the eye as instrument, Cézanne extended them to the object, the visible substance. To paraphrase the question that was uppermost in his mind: What happens when light strikes an object? He sought the answer indomitably, courageously determined to find truth, in countless "sittings with nature." An apparently somewhat reserved man, he evolved with profound artistic conscientiousness an entire philosophy of light and object, perhaps the greatest synthesis of scientific questioning and artistic solution ever conceived. In his last years Cézanne seemed to feel that it was not the medium of oil but the modest watercolor that could most closely reproduce his perceptions without loss. These watercolors (*161*) treat nothing less than light experienced with almost corporeal intensity. They represent the ultimate in Cézanne's artistic expression.

Henri Rousseau (*152, 154*), called "Douanier," was a Sunday Painter of humble origins and uneducated, yet he is now numbered among the great masters. His genuine innocence enabled him to create pictures that represent the basic stuff of life itself. At first, his works were greeted with a condescending smile (because he did not comply with the conventions of perspective); later, they were received with a kind of amazed recognition. The amazement was prompted by the discovery that outside the thin stratum of the civilized and highly educated class, and yet within its very midst, a naive spirit lived and saw and painted, inspired directly by the jungle and the steppes, the savageness and delicacy of the beasts, the brilliance and coldness of the stars.

Paul Gauguin (*158, 159*) was an "exotic" like Douanier Rousseau, with the difference that he did not carry the images of steppes and primeval jungle around within him in his dreams, but sought them out as a voyager to the South Seas. He was a European who mistrusted European civilization and looked to exotic cultures with the conviction that primitive man was closer to paradise and better able to live innocently, in harmony with himself.

Vincent Van Gogh (*157, 162*) was a young missionary from the northern European coalfields, who gave up his mission to follow a path of privation toward the South. He was drawn by the light of the South, which he glorified in his paintings, and to which, after a few years of ceaseless work, he sacrificed his very substance. If there has ever been a painter for whom, in a literal sense, paint stood for "the suffering of light translated into deeds" (Goethe), it is this lonely ascetic.

His life was the life of a secularized priest, and thereby he truly achieved what the German Nazarenes and the English Pre-Raphaelites could only formulate. He had one mission only in life—to become, without sparing himself, the vehicle for expressing the universal power of light and to capture it for all time on canvas.

Ferdinand Hodler (*153, 156*) was in many respects the counterpart of his contemporary Van Gogh. Both were children of poor parents, both lacked proper education. Thrown back on his own resources, Hodler arrived, after many trials, at a kind of vision that in a curious way identified with hills and mountains. An inner logic, similar to that which led Van Gogh to the Mediterranean South, took Hodler to the Swiss Alps. Although by that

145 PIERRE-AUGUSTE RENOIR, BOX AT THE THEATER. 1874. Courtauld Institute of Art, London. Renoir sees a visit to the theater as a kind of mirror reflection: the events on the stage and in the auditorium are reflected in the figure of the spectator, in terms of color, atmosphere, and psychology.

146 EDGAR DEGAS, PLACE DE LA CONCORDE (Portrait of Count Lepic and his daughters). 1873–74. Destroyed (formerly Gerstenberg Collection, Berlin). None of the people depicted—or the vehicles or buildings—is presented in full; they are literally marginal figures. Thus, although the composition has an "empty" center, interest is focused on it—on the normally unnoticed or background city square, which here has the chief role.

147 GEORGES SEURAT (1859–91), SUNDAY AFTERNOON ON THE ILE DE LA GRANDE JATTE. 1885. Detail. Art Institute, Chicago. The *virgules* (comma-shaped brushstrokes) of the Impressionists evolved, in Seurat's hands, into dots of pure color. It is left to the retina to do the mixing; the eye itself is actively engaged in the process of color synthesis.

148 PIERRE BONNARD (1867–1947), NUDE AGAINST THE LIGHT (EAU DE COLOGNE). 1908. Musées Royaux des Beaux-Arts, Brussels. The great heir to the Impressionists experienced light as a gentle diffusion, never as a drama or as dangerously blinding. The lovely young nude benefits from the soft, caressing light, as she sprinkles herself with toilet water. But her form is somewhat distorted by the unusual pose and the unusual perspective. By these very

means Bonnard draws attention to the significant event of light striking the body.

149 GUSTAVE MOREAU (1826–98), THE DANCE OF SALOME. c. 1876. Louvre, Paris. Moreau's leanings were considered "British" or "German" in Impressionist France. Against his Parisian contemporaries, who with increasing thoroughness declared themselves for everyday subject matter and pure appearance, he defended intellectual painting, symbolism, and "sublime," often Biblical, subject matter.

150 SIR EDWARD BURNE-JONES (1833–98), KING COPHETUA AND THE BEGGAR MAID. 1884. Tate Gallery, London. The Pre-Raphaelites sought security in the supposedly purer values of the Middle Ages and the Early Renaissance. They conjured up an idealized world from the past, which they favorably contrasted—on both social and cultural levels—with the 19th-century world of progress.

151 SIR JOHN EVERETT MILLAIS (1829–96), OPHELIA. 1852. Tate Gallery, London. A knowledge of Shakespeare's play alone makes this highly literary work legible. The detail of the picture results from the minute and unselective observation of nature.

152 HENRI ROUSSEAU (1844–1910), THE SLEEPING GYPSY. 1897. Museum of Modern Art, New York. Rousseau is the one great master of the 19th century whom one could call naive in the original sense of the word. His imaginative power flows like a lava stream from beneath the surface, is quite unspoiled, and leads to works whose meanings are extremely difficult to verbalize.

154

Bonnard

time the mountain landscape was spoiled by tourist associations, Hodler saw it in a completely fresh way, and in his best works he fashioned it into a unique, momentous, primeval portrait of earth and sky. Apart from mountain pictures and his favorite theme of Lake Geneva, he created allegorical figure compositions that made an important contribution to Art Nouveau painting.

The Painter Prince and the Bohemian

The position of the artist in society underwent a curious change in the 19th century. The situation of the painter, rather than that of the architect or sculptor, most clearly illustrates the new state of affairs. The change took not one but—as with so many 19th-century developments—two directions. The artist who carried out private commissions for pictures or state commissions for murals and other decorations was able to set himself up successfully in society and could enjoy living in the style of a "painter prince"; one example is Franz von Lenbach (1836–1904) in Munich.

This group of painters had to curry favor with courts, with the powerful, and with the wealthy, and the need to do so was increasingly viewed, as the century wore on, as a detrimental influence, much more likely to weaken the "inner kernel" of art than to nourish it. Many artists, writers, and intellectuals in Western Europe came to believe that rich patrons were not worthy partners in the enterprise of art. They therefore began to reject all suggestions for subjects or themes that came from the outside. In many cases, artists were not even prepared to undertake portrait commissions; they would paint only their own models.

This second group, feeling itself excluded, or wanting to distance itself, from the establishment, and wishing not to be distracted in its search for inner fulfillment, lived, in the so-called Bohemian fashion, lives of poverty, often self-imposed and frequently enough verging on disaster. In the last third of the 19th century, practically every painter who would subsequently be recognized as a great master belonged to the Bohemian group, and an artistic career more and more became associated with the notion of dire penury and unappreciated genius. This latter concept—that of society's failure to appreciate—did not necessarily imply a rejection of the existing social order. More often it arose from the conviction that the artist was necessarily, like the researcher or inventor, ahead of society, that he therefore belonged to the avant-garde, and that he experienced and felt things that received opinion and the great majority were not yet aware of. Not infrequently the artist was considered a martyr to the cause of future developments. This was true for a time of the Impressionist group, particularly of Cézanne and Van Gogh, and also of the Cubists around 1910.

There are a number of reasons for the insecure place of the artist in 19th-century society, not the least of which surely lies in the increasingly problematical effect his work had on society. For it is particuarly when the artist works in oil—that is to say, creating unique originals—that he is furthest from the public he would like to reach. The exclusiveness of the original precludes a wider impact, and photographic reproduction in 1900 was still incapable of anything more than a very crude, if not downright falsified, version of the original. To be sure, photography reproduced proportions correctly, but naturally, being limited to black-and-white, it distorted color relations.

153 FERDINAND HODLER (1853–1918), GRINDEL-WALD GLACIER. 1911. Kunsthaus, Zurich. Mountain painting, which became highly developed in Switzerland and Austria from 1800 on, not as a decorative art for tourists but as an evocation of the "unspoiled mountain homeland" and "symbol of divine creativity," received a new formulation in Hodler's feeling for the mountains. His intense convictions about toughness and independence of mind are embodied in the stone, scree, and rock of the Alps, where untamed, uneroded, unsmoothed forms are still to be found.

154–58 HENRI ROUSSEAU, THE WRITER PIERRE LOTI. c. 1906. Detail. Kunsthaus, Zurich; PAUL CÉZANNE (1839–1906), SELF-PORTRAIT. 1885–87. Trimmed on one side. Kunstmuseum, Bern. FERDINAND HODLER, SELF-PORTRAIT. 1916. Kunstmuseum, Bern; VINCENT VAN GOGH (1853–90), SELF-PORTRAIT. 1890. Trimmed at base. Paris, Louvre; PAUL GAUGUIN (1848–1903), SELF-PORTRAIT WITH HALO. 1889. National Gallery, Washington, D. C. Juxtaposed here are a portrait and four self-portraits by the masters who followed the Impressionists. Instead of impression, however, they looked for expression (particularly Hodler, Van Gogh, and Gauguin), or they evoked exotic forms of life (Gauguin and Rousseau), which they held up to the technically advanced European world as a purer kind of expression.

159 PAUL GAUGUIN, WHEN WILL YOU MARRY? (NAFEA FAA IPOIPO). 1892. Kunstmuseum, Basel. Gauguin sought the earthly paradise and found it in the South Seas. He described it with all the finesse of highly cultivated French painting and succeeded in honoring the primitive culture without false familiarity or condescension.

160 PAUL CÉZANNE, BATHERS BEFORE A TENT. 1883–85. Detail. Staatsgalerie, Stuttgart. Cézanne observes the body in light, his most important theme, with precision and often with an almost scientific coldness and rigor. Here, as often in his work, the figures are elongated. Cézanne's interest lies not in anatomy, but in the body as contoured by light.

161 PAUL CÉZANNE, TREES BY THE WATER. c. 1900. Watercolor. Kunsthaus, Zurich, E. M. Remarque Collection. In Cézanne's later work the small watercolor is as important as the oil. Watercolor enabled him to grasp the transparency and the corporality of light. It is not so much the trees that concern him, but the "crystals of light" between trees and water.

162 VINCENT VAN GOGH, ROAD WITH CYPRESSES. 1890. Rijksmuseum Kröller-Müller, Otterlo. In his last years, Van Gogh frequently painted the night. He saw in it whirling circles of stars, to which the earth responds, most clearly in the flame-like form of the cypresses.

164

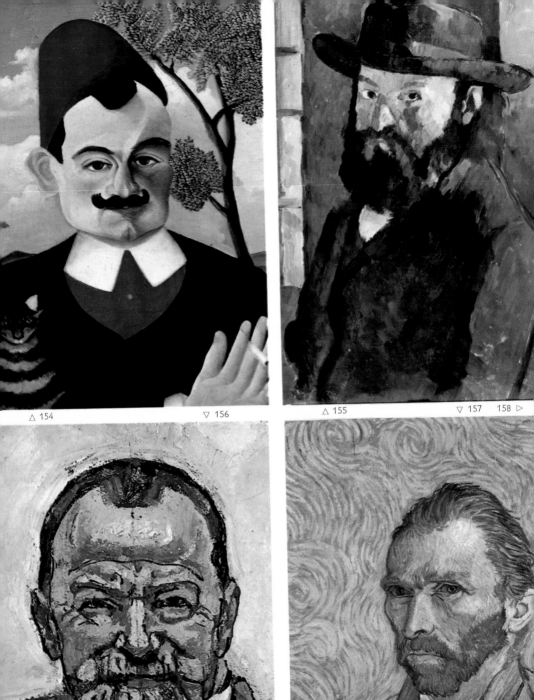

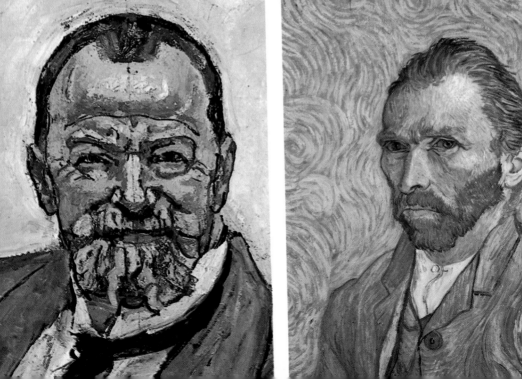

△ 154 ▽ 156 △ 155 ▽ 157 158 ▷

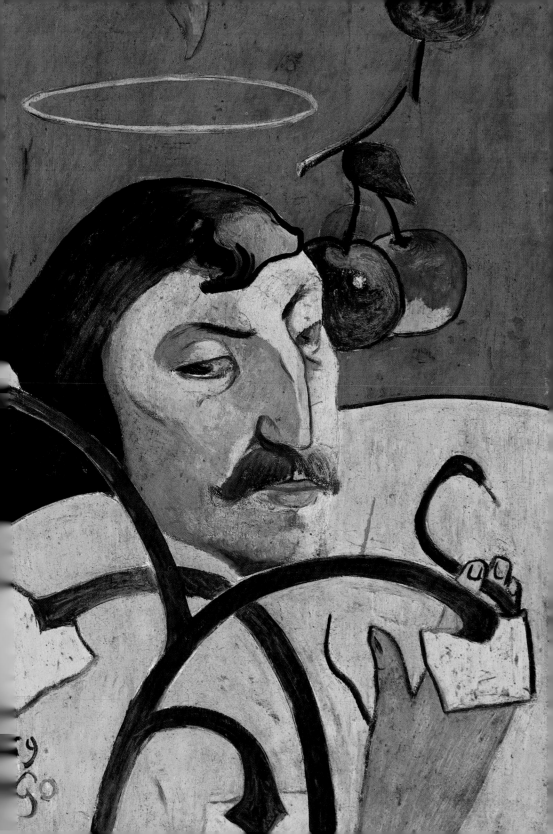

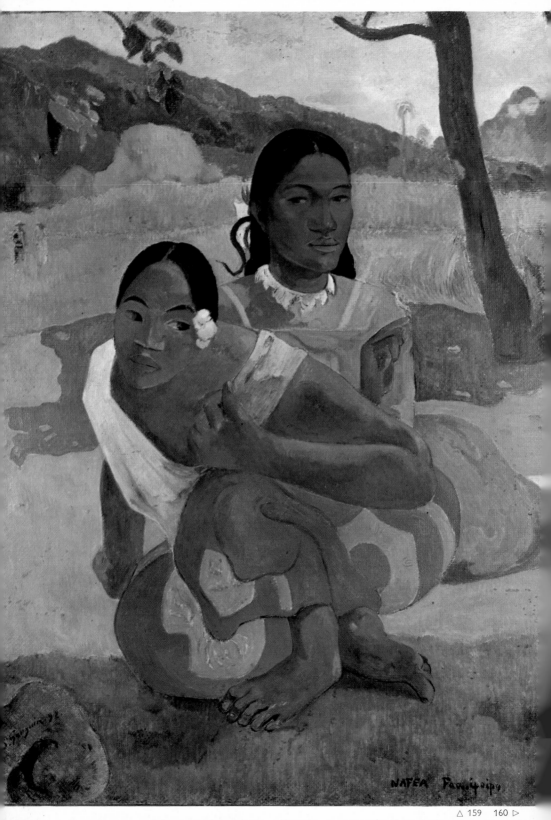

NAFEA Faaipoipo

Above all, photography, capable of enlarging or reducing format at will, tended to produce in the observer a curious lack of respect for the quantitative values of the original. For these reasons, photography as a means of reproduction is not be classed with the *true* reproduction achieved by printing, woodcut, etching, lithography, and other graphic techniques.

Both these factors, the exclusiveness of the original and the distortions of photographic reproduction, contributed in the closing years of the century to a new enthusiasm for the graphic arts. Great painters like Edvard Munch (1863–1944; *164*) and Henri de Toulouse-Lautrec (1864–1901; *166*) now devoted a great deal of their creative energy to woodcuts or lithography, accessible not only to the few but to large numbers of people.

Aubrey Vincent Beardsley (1872–98; *163*) moved even further from 19th-century conventions in his graphic art than Munch or Toulouse-Lautrec. His work is first and foremost a paring down of superfluous elements (halftones, perspective), as though he had taken the maxim "less means more" as his guideline. He often limited himself to black and white, as though determined to challenge photography on its own ground and to expose its dependence on the object and on perspective. His black is never more than line or surface, his white is blindingly empty. This represents the first rejection of the principles of optical illusion, which had influenced pictorial art from the 15th to the 19th centuries and which, at the beginning of the 20th century, were to become more and more the province of photography. For painting, like every other art, would concentrate on expressing what it alone could express. Whole areas of optical phenomena were therefore renounced and left to photography, and painting became involved in a dialogue with itself, in an examination of the methods and the possibilities left to it. It became abstract. The first step, which took place around the *fin de siècle*, was the step from the illusion of the third dimension to surface. The four examples reproduced here (*163–66*) by Beardsley, Munch, Alfons Mucha (1860–1939), and Toulouse-Lautrec, show how much these artists were now concerned with moving away from modeling in depth to working with flat planes.

It was a step that might be considered regressive: the conscious renunciation of a technical mastery Europe had possessed since the 15th century, and a truly surprising development in an age so preoccupied with progress. But precisely because so much was at stake in the repudiation of perspective, the new two-dimensional art needed a support or an excuse, and this was provided by graphics. For printed graphics have always been, by definition, an art of surface planes, like typography. That was why Munch and Toulouse-Lautrec were generally more comfortable giving up the third dimension in their graphics than in their painting. Later, Vassily Kandinsky, too, made his trial of the "less means more" principle, at first in woodcuts; his use of surface area is reminiscent of Munch's technique.

This first exercise in renunciation, so out of character with the contemporary mania for progress, is the great contribution of Art Nouveau graphics. It is a first step, which would be followed after 1910 by others—by all the stages in the rejection of representational art summed up in the term abstraction.

Beardsley, Munch, Toulouse-Lautrec (*163, 164, 166*): examples by these three masters of graphic art, together with a poster by Alfons Mucha (*165*), give some indication of the art of the end of the century. All these works can be described as Art Nouveau (a concept already discussed in the section on architecture). To be sure, Munch and Toulouse-Lautrec were primarily painters, but as graphic artists they were involved in the very important movement, on the threshold of the new century, that attempted to lead art away from conventional easel painting. This tendency is related to the fact that the distinction between "high art" and "consumer art" was becoming blurred; in Art Nouveau, the balustrade of a staircase, the entrance to a Métro station, a book illustration, or a poster are every bit as important as the traditional painting. Glass, weaving, clay, wood, iron, and silver, for so long forgotten or ignored, were all sensitively employed in new ways: to create with an awareness of the individual "nature of materials" became a key concept in these years. It originated with the American architect Frank Lloyd Wright and was a theoretical corner-stone of the Deutscher Werkbund ("craft league") and its offshoots, as well as of the Bauhaus, whose influence was to be so far-reaching in the first half of the new century.

163–66 AUBREY VINCENT BEARDSLEY (1872–98), ISOLDE. 1898. Book illustration; EDVARD MUNCH (1863–1944), WOMEN ON THE BEACH. 1898. Colored woodcut; ALFONS MARIA MUCHA (1860–1939), SALON DES CENT. 1836. Exhibition poster. Colored lithograph; HENRI DE TOULOUSE-LAUTREC (1864–1901), MARCELLE LENDER, EN BUSTE. 1895. Colored lithograph. Art Nouveau graphics are not a minor art or mere offshoot of the movement—quite the contrary. Printing techniques and book printing were very important to the artists of the *fin de siècle* because they exploit surface over depth. It is in graphic art that three-dimensional perspective was first discarded in favor of an art of pure surface. The rejection of perspective would play an important part in the painting of the 20th century, especially in the development of abstraction.

ISOLDE

ART AND THE RANGE OF CIVILIZATION

No period before the 19th century had engaged in such a lively exchange of goods, works, and ideas beyond the frontiers of Europe. Any political or economic history of this century in Europe would be incomplete without mention of the other continents, and the same applies, of course, to the history of art. For European architecture and art of the period did not stop with revivals, adaptations, or borrowings from Roman, Gothic, Renaissance, and Baroque styles. With the same curiosity and eagerness with which it explored its own history, Europe in the 19th century ventured forth to other lands.

The most significant examples of stylistic influence from outside Europe were as follows:

Architecture	Moorish or Islamic	Most commonly adopted for spa resorts
	Indian	Royal Pavilion at Brighton, 1815–18
	Chinese and Japanese architecture	Influential after William Chambers' use of these styles (Pagoda in Kew Gardens, 1761–62)
Painting	Islamic	Eugène Delacroix (*Odalisques*)
		J-A-D. Ingres (*The Turkish Bath*)
	Japanese	Édouard Manet (*Portrait of Emile Zola*)
		Vincent Van Gogh (*Woman at "Le Tambourin"*)

These few examples represent a wide current of influences from abroad that ran through the whole century, embracing all media, particularly crafts and design, which were influenced profoundly yet superficially at the same time. The impact of foreign cultures can be discerned at all levels, from the naive narrative piece about the white adventurer in exotic climes (*110*) to the serious confrontation with an alien life style, as realized, for example, in works by Ingres, Delacroix, and Van Gogh.

But what of influences in the other direction? What did the non-European world receive from Europe? Strangely enough, the record of this debt was not as accurately kept as that of Europe's borrowings from the rest of the world. This is to say that the taking, but not the giving, was observed and recorded.

179

Stylistic Imports and Exports of the Growing Colonial Powers

In point of fact, the Europeans always brought something with them when they entered a new non-European area. It is equally clear that what was taken to such places was, in the first place, superiority in weaponry on land and sea, and, second, an abundance of goods. Both were symptomatic of a European life style characterized by the successive expansion of range in all spheres (range of weapons; range of information; range of buildings, from the tower and the hall to the bridge and railroad network; range of trading relations). This expansion occurred long before the true advent of colonialism and constituted what Europe would increasingly consider as the common European achievement. It is an achievement that, inevitably, conditioned art as well. The effects of range expansion had always been available to art to accept or reject: In the 15th and 16th centuries, for instance, the science of perspective was embraced by Dürer, rejected by Grünewald. In the 19th century, the ideal of photographic accuracy was embraced by the Classicists (Ingres), the idealists (Feuerbach), and the Pre-Raphaelites (Burne-Jones, Millais); it was rejected by the Romantics (Delacroix), the realists (Courbet), and the Impressionists (Manet, Monet). But even rejection implies conditioning; it is one of a number of responses to a particular situation.

To return to the interchange between Europe and the non-European world: ultimately, this represented not simply a confrontation of weapon with weapon, ship with ship, one kind of fabric or one art form with another. Rather, it was a confrontation of two life styles, in which one, the European, was always dominant, because it commanded a more extended range. This imbalance of the forces of opposing civilizations led to unequal reactions in 19th-century cultural interchange. On the part of the Europeans, reception of alien influences was voluntary and therefore not serious; it was in the nature of play. But for non-Europeans, the same process almost invariably occurred under threat of superior force or the pressure of superior status; it was not a question of play, then, but of compulsion. (One example, mentioned in the Introduction, is the European-style decoration of the Palace of Beylerbey on the Bosporus for the visit of the Empress Eugénie in 1869.)

Outside influences on Europe usually encompassed the manner without the means; the influence on the outside world exercised by Europe consisted of manner plus means.

The 19th-century European could, if he wished, borrow or adapt the art of, say, India or the Middle East, but he was not obliged to. He might imitate the manner (the themes and motifs) but it was unlikely he would condescend to take over the means (primitive tools and "backward" methods). On the contrary, with his own highly developed methods he could copy exotic motifs with short-cut rapidity and amazing accuracy; yet in the process

180

he would not have produced anything credible or genuine, because he had by-passed the native manner (production process) in a single bound. An obvious example is the machine-made "oriental" carpet.

The non-European, on the other hand, probably experienced the European 19th-century life style fully and truly as a style—that is, as a coherent pattern woven together from various strands, out of unified manner and means, beginning with armament and methods of transport and communication and going on to hygiene measures and art forms (with their puzzling principles of perfect perspective and precise verisimilitude). It would be impossible for the non-European to take up a free, playful, or selective attitude to a European style, which was always a manifestation of the greater range and therefore of the domination of European civilization. The only reasonable response to this domination was that of willingness to learn, whether this derived from genuine fascination, from sheer calculation (with secret reservations), or from fear.

Thus, it is not really paradoxical that non-Europeans in the 19th century absorbed from Europe a "style" in the widest sense of the word. The adoption could be carried out with more or less talent, or rightly or wrongly, but not "genuinely or non-genuinely." Europeans on the other hand, attempted voluntarily and playfully to take over styles from here or there, but because their more advanced methods permitted short cuts to production, they generally found themselves left with the manner without the means. Central to the question of their borrowings from others were the concepts of genuine and false, not right or wrong.

Changes in the Earth's Surface

The conventional division of the visual arts into architecture, sculpture, and painting, familiar to us since the Renaissance, has never, for all its undeniable usefulness, been able to encompass more than a portion of the significant art production of an era. It has proved particularly inadequate in discussions of the arts concerned not with creating a single structure, a mural, an interior, or a building, but a total environment. Two environmental creations long known in Europe are city fortifications and gardens.

Interestingly, artistic qualities are more readily perceived in medieval defenses than in their modern equivalent. The reason is probably that the practical aspect of medieval fortification looks so innocuous to modern eyes that their effect for us is purely picturesque. More modern defense works, though—for instance, the 17th-century star-shaped defenses of Maréchal Vauban—are not yet included in the category of environmental construction that the historian is inclined to examine for its artistic as well as its engineering and other

merits. By contrast, the Italian (16th century), the French (17th century), and the English garden (18th century) have long been acknowledged and judged as important manifestations of the visual arts.

The 19th century, too, created environmental changes, far-reaching enough for us to speak quite literally of changes in the earth's surface (for the first time since the pyramids?). The changes with the greatest effect were the canal systems, particularly in England, Western and Central Europe, and later also in colonial territories (Suez Canal), and the railroads, which grew up all over Europe and later spread to every continent.

It was the 19th century's achievement to improve on the old Roman road with two further communication systems, and both transformed entire countrysides. Especially in the Alpine valleys of Switzerland and Austria, the railway, with its bridges, inclines, tunnels, and stations, was often enough the only formative art element alongside the plastic elements of nature itself—glaciers, snow, and water. In the second half of the 19th century, the railway engineer became a landscape gardener on a grand scale. His reshaping of the landscape was so monumental that the conventional canons of art, with their division into three genres, have up to the present failed to generate suitable criteria for it.

Handwriting as a Folk Art

It is not too much of an exaggeration to say that Europe, especially Western Europe, lost or abandoned in the course of the 19th century most of the old folk arts of carving, decorative painting, weaving, and embroidery; what replaced them was cursive handwriting for all. The number of illiterates declined, particularly in the Protestant North, and reading and writing became common property. The more gifted person developed a personal script, in and through which he could express all that made him an individual. In other words, what was expressed in more exotic lands through the movements of the whole body—for instance in dancing—was expressed by the 19th-century Westerner exclusively in a delicate personal choreography, through the "dance" of the right hand. At least for the urbanized part of Europe's population, the carved utensil, the painted chest, the woven and embroidered folk costume were no longer folk arts that commanded respect; instead, the art of the handwritten letter became the true folk art of the 19th century.

The Tourist and the Native

Tourist and "native"—these were two "types" of the 19th century. The tourist had at his command all the advantages of the latest extensions of range—as a traveler by sea or rail,

in his possession of information, in his knowledge of scientific and medical phenomena, in his familiarity with geography and history. He was interested in the "vertical" relationships of history and the "horizontal" interconnections of nature, culture, technology, and politics. He visited neighboring countries at the same level of culture—Englishmen, for instance, went to France or Germany—but as a tourist he was really only in his element when confronting the exotic world. The exotic native was a creature of limited civilized range, to whom the tourist felt himself superior, but whose way of life he admired as less problematical and freer from pressures than his own.

Two model tourists in the century's first decades were Goethe and the scientist and philosopher Alexander von Humboldt. The former found his "exotics" in the Alpine people of Switzerland, the latter among the jungle tribes of South America. It is true that Goethe, on his Swiss, and especially his Italian, journeys, generally followed the traditional route of the Grand Tour, or educational journey, of the 17th and 18th centuries, but his interests were so broad—history, geography, geology, customs—that he became the prototype of all that the 19th-century tourist hoped to be. Side by side with the political polarization of the period (monarchists—republicans), then, there appeared a cultural polarity (tourists—"exotics"), and this was closely connected with art, for the tourist was always looking for permanent witnesses to man's original way of life, and he often found them in the arts or crafts of foreign peoples.

It was exciting for a Western "native" to make his appearance in the midst of the tourists' own world, as the painter Douanier Rousseau did in Paris. He lived in the metropolis but remained a primitive to the extent that he neither commanded nor needed the usual techniques of extended range (such as perspective). He represented the primal spirit amid a world confident of everything except its ability to live and create with the originality of primitive man; thus his fascination.

Since the monument-conscious 19th century was inclined to set up monuments to all important phenomena, it is appropriate to end with this question: Did the tourist receive a suitable monument? You will find one, in fact, in almost every European city. Not in the very center, but on the perimeter, often on the site of old fortifications that were later turned into public gardens. There will stand a memorial, complete with plinth and protected under its own little cast-iron roof: the barometer. It is equipped with precise data concerning the geographical latitude of the city, its height above sea-level, and so forth—a monument to the European tourist of the 19th century.

BIBLIOGRAPHY

GENERAL

Aslin, Elizabeth. *The Aesthetic Movement: Prelude to Art Nouveau.* London: Elek; New York: Praeger, 1969.

Badt, Kurt. *Wolkenbilder und Wolkengedichte der Romantik.* Berlin: De Gruyter, 1960.

Beenken, Hermann Theodor. *Das 19. Jahrhundert in der deutschen Kunst, Aufgaben und Gehalte: Versuch einer Rechenschaft.* Munich: Bruckmann, 1944.

Evers, Hans Gerhard. *Vom Historismus zum Funktionalismus.* Baden-Baden: Holle, 1967. (Kunst der Welt: Die Kulturen des Abendlandes.)

Grote, Ludwig, ed. *Historismus in Architektur und bildender Kunst im 19. Jahrhundert.* Munich: Prestel, 1965. (Fritz-Thyssen-Stiftung.)

Hofmann, Werner. *The Earthly Paradise: Art in the Nineteenth Century.* New York: Braziller, 1961. Also issued as *Art in the Nineteenth Century.* London: Faber and Faber, 1961.

Hofstätter, Hans H. *Symbolismus und die Kunst der Jahrhundertwende.* Cologne: DuMont Schauberg, 1965.

Lankheit, Klaus. *Revolution und Restauration.* Baden-Baden: Holle, 1965. (Kunst der Welt: Die Kulturen des Abendlandes.)

Neue Pinakothek. *World Cultures and Modern Art.* Munich, 1972. Exhibition catalogue.

Nochlin, Linda. *Realism.* Baltimore and Harmondsworth: Penguin (Pelican), 1971.

Petzet, Detta and Michael. *Die Richard-Wagner-Bühne Ludwigs II.* Munich: Prestel, 1970. (Fritz-Thyssen-Stiftung.)

Pevsner, Nikolaus. *Pioneers of Modern Design: From William Morris to Walter Gropius.* 3d ed. Baltimore and Harmondsworth: Penguin (Pelican), 1960.

– *Sources of Modern Architecture and Design.* London: Thames and Hudson; New York: Praeger, 1968.

– *Studies in Art, Architecture, and Design.* 2 vols. London: Thames and Hudson; New York: Walker, 1968.

Reinle, Adolf. *Die Kunst des 19. Jahrhunderts: Architektur, Malerei, Plastik.* Frauenfeld: Huber, 1962. (Kunstgeschichte der Schweiz, 4.)

Scheffler, Karl. *Das Phänomen der Kunst: Grundsätzliche Betrachtungen zum 19. Jahrhundert.* Munich: List, 1952.

Selz, Peter, and Constantine, Mildred, eds. *Art Nouveau: Art and Design at the Turn of the Century.* New York: Museum of Modern Art, 1960. Exhibition catalogue.

Wittkower, Rudolf. *Architectural Principles in the Age of Humanism.* 3d rev. ed. London: Tiranti, 1962; New York: Random House, 1965.

Zeitler, Rudolf. *Klassizismus und Utopia: Interpretation zu Werken von David, Canova, Carstens, Thorvaldsen, Koch.* Stockholm: Almqvist and Wiksell, 1954.

Zeitler, Rudolf, et al. *Die Kunst des 19. Jahrhunderts.* Berlin: Propyläen, 1966. (Propyläen Kunstgeschichte, 11.)

ARCHITECTURE

Besset, Maurice. *Gustave Eiffel, 1832–1923.* Paris: Hatier, 1957.

Carl, Bruno. *Klassizismus 1770–1860.* Zurich: Berichthaus, 1963. (Die Architektur der Schweiz.)

Chadwick, George F. *The Park and the Town: Public Landscape in the 19th and 20th Centuries.* London: Architectural Press; New York: Praeger, 1966.

– *The Works of Joseph Paxton.* London: Architectural Press, 1961.

Clark, H. F. *The English Landscape Gardens.* London: Pleiades Books, 1948.

Collins, George R. *Antonio Gaudi.* London: Mayflower; New York: Braziller, 1960. (The Masters of World Architecture.)

Connely, W. *Louis Sullivan as He Lived.* New York: Horizon, 1960.

Fitch, James Marston. *Architecture and the Aesthetics of Plenty.* New York: Columbia University Press, 1961.

Geist, Johann Friedrich. *Passagen.* Munich: Prestel, 1969. (Fritz-Thyssen-Stiftung.)

Giedion, Sigfried. *Space, Time, and Architecture: The Growth of a New Tradition.* 3d ed. Cambridge, Mass.: Harvard University Press; London: Oxford University Press, 1954.

Hammer, Karl. *Jakob Ignaz Hittorff.* Stuttgart: A. Hiersemann, 1968.

Hautecoeur, Louis. *Histoire de l'architecture classique en France.* 5: *Revolution et Empire, 1792–1815;* 6: *La restauration et le gouvernement de juillet, 1815–1848;* 7: *La fin de l'architecture classique, 1848–1900.* Paris: Picard, 1953–57.

Hederer, Otto. *Karl von Fischer.* Munich: Callwey, 1960. (Neue Schriftenreihe des Stadtarchivs München, 12.)

– *Leo von Klenze: Persönlichkeit und Werk.* Munich: Callwey, 1964.

Hitchcock, Henry-Russell. *Architecture, 19th and 20th Centuries.* Baltimore and Harmondsworth: Penguin, 1958. (Pelican History of Art, 15.)

– *Early Victorian Architecture in Britain.* New Haven, Conn.: Yale University Press, 1954; London: Architectural Press, 1955.

– "Victorian Monuments of Commerce." *Architectural Review* 105 (1949): 61–74.

Hôtel de Sully. *Eugène Viollet-le-Duc, 1814–1879.* Paris, 1965. Exhibition catalogue.

Kaufmann, Emil. *Architecture in the Age of Reason: Baroque and Post-Baroque in England, Italy, and France.* Cambridge, Mass.: Harvard University Press; London: Oxford University Press, 1955.

– "Three Revolutionary Architects: Boullée (1728–1799), Ledoux, and Lequeu." In *Transactions of the American Philosophical Society* NS 42, 43, pp. 431–564. Philadelphia, 1952.

Kreisel, H. *Die Schlösser Ludwigs II. von Bayern.* Darmstadt: Schneekluth, 1954.

Langner, J. "Ledoux und die 'fabriques': Voraussetzungen der Revolutionsarchitektur im Landschaftsgarten." *Zeitschrift für Kunstgeschichte* 26 (1963).

Peisch, Mark L. *The Chicago School of Architecture.* London: Phaidon, 1964; New York: Random House, 1965.

Pérouse de Montclos, Jean Marie. *Étienne-Louis Boullée, 1728–1799: De l'architecture classique à l'architecture revolutionnaire.* Paris: Arts et métiers graphiques, 1969.

Plagemann, Volker. *Das deutsche Kunstmuseum 1790–1890.* Munich: Frestel, 1967. (Fritz-Thyssen-Stiftung.)

Quitzsch, Heinz. *Die ästhetischen Anschauungen Gottfried Sempers.* Berlin: Akademie, 1962.

Richardson, Albert Edward. *Monumental Classic Architecture in Great Britain and Ireland.* London: Batsford, 1914.

Rosenau, Helen, ed. *Boullée's Treatise on Architecture.* London: Tiranti, 1953.

Royal Institute of British Architects. *One Hundred Years of British Architecture, 1851–1951.* London, 1951. Exhibition catalogue.

Summerson, John. *Architecture in Britain, 1530–1830.* Baltimore and Harmondsworth: Penguin, 1953. (Pelican History of Art, 3.)

– *John Nash (1757–1835), Architect of King George IV.* 2d ed. London: Allen and Unwin, 1949; New York, Macmillan, 1950.

– *Sir John Soane, 1753–1837.* London: Art and Technics; New York: Anglobooks, 1952.

PAINTING AND SCULPTURE

Bandmann, Günter. "Das Exotische in der europäischen Kunst." In *Der Mensch und die Künste: Festschrift Heinrich Lützeler,* edited by Günter Bandmann, et al. Düsseldorf: Schwann, 1962.

Beardsley, Aubrey. *The Early and Later Work.* 2 vols. New York: Da Capo, 1967.

Boime, Albert. *The Academy and French Painting in the Nineteenth Century.* London and New York: Phaidon, 1971.

Brion, Marcel. *Romantic Art.* London: Thames and Hudson; New York: McGraw-Hill, 1960.

Champa, Kermit S. *German Painting of the 19th Century.* New Haven, Conn.: Yale University Art Gallery, 1970. Exhibition catalogue.

Cooper, Douglas. *Toulouse-Lautrec.* London: Thames and Hudson; New York: Abrams, 1956.

Danielsson, Bengt. *Gauguin in the South Seas.* London: Allen and Unwin; New York: Doubleday, 1965.

Elsen, Albert. *Rodin*. New York: Museum of Modern Art, 1963.

Friedländer, Walter. *David to Delacroix*. Cambridge, Mass.: Harvard University Press; London: Oxford University Press, 1952.

Fry, Roger. *Cézanne: A Study of His Development*. London: Hogarth; New York: Macmillan, 1927. Reprint, New York: Farrar, Strauss (Noonday), 1958.

Gage, John. *Color in Turner: Poetry and Truth*. London: Studio Vista; New York: Praeger, 1969.

Ganz, Paul. *Die Zeichnungen Hans Heinrich Füsslis (Henry Fuseli)*. Bern-Olten: Urs Graf, 1947.

Hamilton, George Heard. *Manet and His Critics*. London: Oxford University Press; New Haven, Conn.: Yale University Press, 1954.

– *Painting and Sculpture in Europe, 1880–1940*. Rev. ed. Baltimore and Harmondsworth: Penguin, 1972. (Pelican History of Art, 29.)

Herron Museum of Art. *The Pre-Raphaelites*. Indianapolis, 1964. Exhibition catalogue.

Larkin, Oliver. *Daumier: A Man of His Time*. London: Weidenfeld and Nicolson; New York: McGraw-Hill, 1966.

Leymairie, Jean. *Corot: A Biographical and Critical Study*. Geneva: Skira, 1966.

Licht, Fred S. *Sculpture: The Nineteenth and Twentieth Centuries*. Greeenwich, Conn.: New York Graphic Society; London, Michael Joseph, 1967.

Lutterotti, Otto R. von. *Joseph Anton Koch, 1768–1839*. Berlin: Deutscher Verein für Kunstwissenschaft, 1940.

Mack, Gerstel. *Gustave Courbet*. New York: Knopf, 1951; London: Hart-Davis, 1952.

Malraux, André. *Saturn: An Essay on Goya*. London and New York: Phaidon, 1957.

Museum of Modern Art. *Odilon Redon. Gustave Moreau. Rodolphe Bresdin*. New York, 1962. Exhibition catalogue.

Novotny, Fritz. *Painting and Sculpture in Europe, 1780–1880*. Baltimore and Harmondsworth: Penguin, 1960. (Pelican History of Art, 20.)

Novotny, Fritz, and Dobai, Johannes. *Gustav Klimt*. London: Thames and Hudson; New York, Praeger, 1968.

Peacock, Carlos. *John Constable: The Man and His Work*. Greenwich, Conn.: New York Graphic Society; London: Baker, 1965.

Piper, David. *Painting in England, 1500–1880*. Rev. ed. Baltimore and Harmondsworth: Penguin (Pelican), 1965.

Renoir, Jean. *Renoir, My Father*. Boston: Little, Brown; London: Collins, 1962.

Rewald, John. *The History of Impressionism*. New York: Museum of Modern Art, 1961.

– *Post-Impressionism from Van Gogh to Gauguin*. New York: Museum of Modern Art, 1956.

Schiff, Gert. *Zeichnungen von Johann Heinrich Füssli, 1741–1825*. Zurich: Fretz und Wasmuth, 1959.

Seitz, William. *Claude Monet*. London: Thames and Hudson; New York: Abrams, 1960.

Terrasse, Antoine. *Bonnard: A Biographical and Critical Study*. Geneva: Skira, 1964.

Wildenstein, Georges. *Ingres*. London and New York: Phaidon, 1954.

INDEX

Descriptions of the illustrations are listed in boldface type

186

189